GRANDMA MOSES

25 Masterworks

by Jane Kallir

Harry N. Abrams, Inc. • Publishers

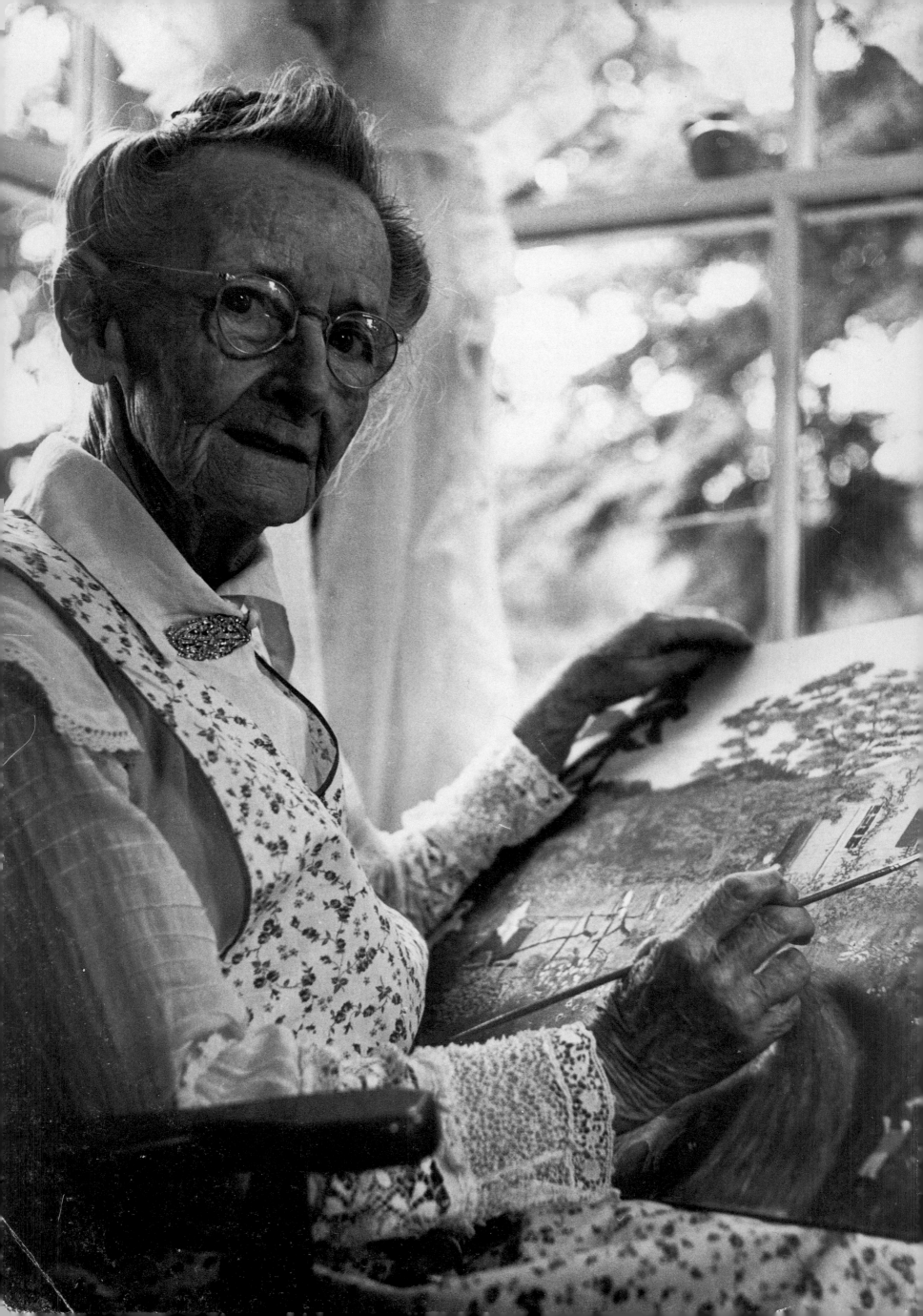

GRANDMA MOSES IN CONTEXT

Anna Mary Robertson Moses, better known as Grandma Moses, is arguably the greatest American folk painter of the twentieth century. She is without a doubt the most famous such artist, and possibly one of the most famous and accomplished women of all time. Moses was also the first artist to become a media superstar and the first American painter to achieve a significant international reputation in the post–World War II era. Nevertheless, despite (or perhaps because of) these impressive achievements, and a biography that could not have been more perfect had it been crafted by a Hollywood screenwriter, Moses remains something of an anomaly within the context of modern art history.

Moses' extreme fame seemingly lifted her out of her original folk art context, creating a perceptual gap between her generation of self-taught artists and the nineteenth-century folk tradition from which they all descended. Today, as the significance of twentieth-century self-taught art is being reappraised, Moses continues to stand apart, an outsider even within this genre of outsiders. Nor, despite admirable strength of character and integrity of vision, has Moses been heralded by feminist art historians, possibly because they are put off by the quaintness of the artist's public persona. Moses the artist is, however, no anomaly, even if the extraordinary circumstances of her late-life career are unique. Her work belongs to a long and rich tradition of American folk art, as exemplified both in this century and before.

To understand Grandma Moses, in fact, one must place her work not only within the context of the American folk tradition, but within that of the modernist mainstream, which over the course of this century has periodically picked out bits from the folk tradition to use for its own ends. Prior to the Renaissance, little distinction was made between high art and low art, fine art and craft. Over the course of the ensuing centuries, however, an elitist tradition developed which privileged the work of certain artists over that of the common folk. This elitist tradition was codified and disseminated through various institutions of patronage and education. Folk art, then, was a catch-all category for the myriad forms of creation that fell outside the system of high-art patronage and education.

During the first century of its existence, the United States was woefully lacking in high-art institutions. The first American museums were not founded until the 1870s, and artists who wanted to learn European academic ways had to travel across the Atlantic. As a result, America by the mid nineteenth century had spawned a significant class of native folk painters. Largely or completely self-taught, these artists combined ele-

ments of crafts and fine art traditions. Often, they began by doing decorative work such as sign or carriage painting. They absorbed the rudiments of academic style second hand, through engravings, or if they were lucky, apprenticed briefly with more formally educated colleagues. Much of the output of these so-called limners consisted of portraits, for which there was a constant demand in the days before photography. Other pictorial records—of ships, farms, or prized livestock —were less popular though not uncommon.

The advent of photography and commercial lithography in the second half of the nineteenth century effectively destroyed the market for these homespun portraitists. Yet, paradoxically, the concomitant proliferation of commercially disseminated imagery stimulated the creativity of amateur self-taught painters. Art schools, museums, and art supply stores furthered this trend.

Grandma Moses, born Anna Mary Robertson on September 7, 1860, was a member of that watershed generation of amateur painters who came of age after the heyday of the professional limner, but long before the penetration of everyday life by the modern media. Living her life on remote farms, she remained physically and intellectually beyond the reach of mainstream culture. When she began to paint, she did so for pleasure, and with little thought or realistic hope of significant acclaim or remuneration.

Like most of the self-taught painters who would come to wider attention in the first half of the twentieth century, Moses was prevented by economic circumstance from pursuing a lifelong interest in art. Although as a child she loved to draw "lambscapes," and a teacher once praised her maps, Moses was taught to see such pursuits as frivolous. Instead, a strict mother (Fig. 3) inculcated in her the skills needed to survive on a farm. Even routine schooling was a luxury often dispensed with: sewing, washing, making soap, and cooking were the sorts of tasks a girl of Anna Mary's social station had to master. Her taste for pretty things found expression principally in "fancy work," decorative sewing, hooked rugs, and, whenever she could find an excuse, in painted embellishments on utilitarian objects such as trays, jugs, or even birthday cakes.

Russell King Robertson, Anna Mary's father (Fig. 2), had a flax mill and farm in Greenwich, a small community in upstate New York about thirty miles northwest of Bennington, Vermont. Whereas Anna Mary's five brothers could help their father at the mill and on the farm, she and her four sisters were increasingly seen to be a burden. At the tender

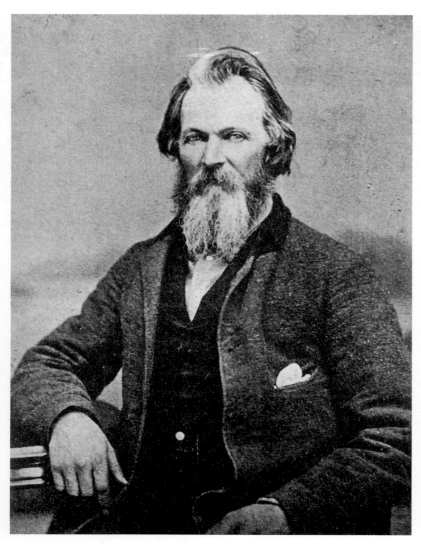

Fig. 2. Anna Mary's father, Russell King Robertson. c. 1860. Photograph

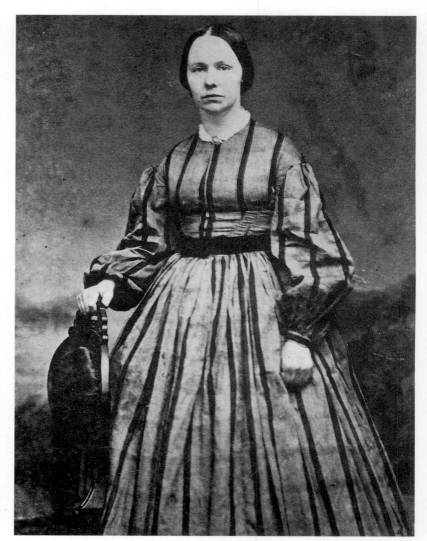

Fig. 3. Anna Mary's mother, Mary Shannahan Robertson. c. 1860. Photograph

age of twelve, Anna Mary went to work as a "hired girl" on a neighboring farm, helping a wealthier family with the household chores. She was to pursue this sort of work for the next fifteen years until, at the age of 27, she met a hired man, Thomas Salmon Moses, whom she married (Figs. 4 and 5).

The year was 1887, and Thomas had been told that the Reconstruction-era South was a land of opportunity for Yankees such as himself. Within hours of their wedding, the couple was on a train headed for North Carolina, where Thomas had secured a job managing a horse ranch. However, he and his bride never made it beyond Staunton, Virginia. Here they stopped for the night and were persuaded to take over as tenants on a local farm. Anna Mary immediately fell in love with the beautiful Shenandoah Valley—her chilly New York State home (albeit mountainous) would forever after seem a "swamp" by comparison. Life was not always easy, though. Anna Mary, who believed in pulling her weight, bought a cow with her own savings and supplemented the family income by churning butter. Later, when times were tough, she made and sold potato chips. She gave birth to ten children, of whom only five survived infancy. Still, the family prospered, eventually earning enough to buy their own farm.

Anna Mary Moses, known by then as "Mother Moses" to many of her neighbors, would happily have spent the rest of her life in Virginia, but Thomas was homesick. In 1905, he persuaded his wife to return North. "I don't think a bit has changed since we left," Anna Mary commented, "the gates are hanging on one hinge since I went away." She and Thomas

bought a farm in Eagle Bridge, not far from her birthplace. They named it "Mount Nebo"—prophetically, after the Biblical mountain where Moses disappeared. It was on this farm, in 1927, that Thomas Moses died of a heart attack.

Anna Moses was not one to sit idle. Though all her children were grown, there was still plenty of work to be done on the farm. Later she would joke, "If I didn't start painting, I would have raised chickens." Or, upon further reflection, "I would rent a room in the city some place and give pancake suppers." In 1932, Moses went to Bennington to take care of her daughter Anna, who was suffering from tuberculosis. It was Anna who showed her mother a picture, embroidered in yarn, and challenged her to duplicate it. So Anna Mary Robertson Moses began stitching what she called "worsted" pictures (Fig. 14) and giving them away to anyone who'd have them. When Moses complained that arthritis made it hard for her to hold a needle, her sister Celestia suggested she paint instead. In this casual manner, the career of Grandma Moses began.

Of course, Moses had painted from time to time before. Her earliest datable painting is a large fireboard, done in 1918 (Fig. 6). Ever practical, she painted this landscape only because, in redoing the parlor, she did not have sufficient wallpaper to cover the board that, in summer, is placed in front of the dormant fireplace. Once, she saved a bit of canvas from an old threshing machine cover to paint on. Moses recalled that Thomas had admired her artwork, and she liked to think his spirit was watching over her, offering approval if not outright guidance. At any rate,

Fig. 4. *Anna Mary Robertson Moses as bride. 1887. Photograph*

Fig. 5. *Thomas Salmon Moses as bridegroom. 1887. Photograph*

a few years after her daughter Anna died, Moses returned to Eagle Bridge and started painting in earnest.

Soon Moses had more paintings than she could realistically make use of. She sent some along to the Cambridge country fair, along with her canned fruits and jams. "I won a prize for my fruit and jam," she sardonically noted, "but no pictures." Here Moses' painting career might have

Fig. 6. *Fireboard. 1918. Housepaint on paper, 32¼ x 38¾" (82 x 98.4 cm).*
Courtesy Grandma Moses Properties Co., New York. Kallir 1

foundered. For, much as she loved art, Anna Mary Robertson Moses was above all a sensible woman, and to pursue art for art's sake alone would, by and by, have come to seem a petty indulgence. But, in 1936 or 1937, Caroline Thomas, the wife of the druggist in the neighboring village of Hoosick Falls, invited Moses to contribute to a women's exchange she was organizing.

Moses' paintings sat in the drugstore window, gathering dust next to crafts and other objects created by local homemakers, for several years. Then, during Easter week of 1938, a New York City collector named Louis Caldor chanced through town. Caldor traveled regularly in connection with his job as an engineer for the New York City water department, and he was in the habit of seeking out native artistic "finds." The paintings in the drugstore window caught his eye; he asked to see more and ended up buying the whole lot. He also got the artist's name and address and set off to meet her in person.

Moses' family clearly thought Caldor was crazy when he told their Grandma he'd make her famous. And indeed, for the next few years, it seemed the family was right. Caldor brought his trove of Moses paintings to New York City and began doggedly making the rounds of museums and galleries. Even those who admired the work lost interest when they heard the artist's age. Turning 78 in 1938, Moses hardly seemed worth the effort and expense involved in mounting an exhibition; her life expectancy was such that most dealers felt they would never reap a profit on their initial investment. Still, Caldor persisted, and in 1939 he had his first limited success: The collector Sidney Janis selected three Moses

Fig. 7. *Grandma Moses and Carolyn Thomas at Gimbels Auditorium. November 14, 1940. Photograph by Louis J. Caldor*

vention at first focused on the creations of nineteenth-century limners and artisans. But by 1927, the quest for a living exemplar of the genre—an American Rousseau, as it were—bore fruit. At the urging of the artist Andrew Dasburg, the jury of the Carnegie International agreed to accept the work of a common house painter, John Kane, for inclusion in that prestigious annual exhibition.

Kane's sudden good fortune—fostered by such art-world luminaries as Duncan Phillips and Mrs. John D. Rockefeller, and derided as a fraud by the tabloid press and a number of disgruntled trained artists—paved the way for the emergence of other kindred talents. By 1938, the Museum of Modern Art had enough for a whole show, "Masters of Popular Painting." Included, in addition to Kane and Rousseau, was a recent discovery, the brilliant African-American painter Horace Pippin. The Museum's founding director, Alfred Barr, was bold enough to state that the history of modern art—and his museum's mandate—consisted of three distinct but equal strands: Surrealism, abstraction, and self-taught art.

It was within this rather august context that Anna Mary Robertson Moses made her public debut at the Galerie St. Etienne in October 1940. Otto Kallir had titled the exhibition "What a Farmwife Painted," thinking that the artist's name, completely unknown, did not merit attention. It was only some months later that a journalist, interviewing friends in Eagle Bridge, came upon and then popularized the local nickname "Grandma Moses."

The St. Etienne exhibition, though well publicized and well attended, was only a modest success. What really got Moses' career rolling was a Thanksgiving Festival organized by Gimbels Department Store shortly after the St. Etienne show closed. A substantial group of paintings was reassembled at Gimbels, and the artist was invited to come to New York. In her little black hat and lace-collared dress, and accompanied by the proprietary Caroline Thomas, Moses (perhaps remembering her experiences at the country fair) delivered a forthright public address on her jams and preserved fruits (Fig. 7). The hard-boiled New York press corps was delighted, and the legend of Grandma Moses was born.

Until this moment, there was nothing to distinguish Moses from the other self-taught painters, such as Kane, Pippin, and Morris Hirshfield, who had been discovered in the preceding decade or so. Yes, it was true that her style was different from that of the others, but then this is one of the hallmarks of contemporary folk art. Since self-taught artists, by definition, remain remote from academic tradition, they make up their own styles from scratch. This does not, of course, mean that such artists are completely uninfluenced: Kane and Rousseau went to museums and copied art books, and Moses collected magazine clippings and greeting cards from which she extracted figural vignettes. But each of these artists interpreted and integrated his or her respective source material in a personal manner, rather than conforming to predetermined pictorial or formal dictates.

Folk or self-taught art is a category largely defined in the negative: It is not academic, it is not mainstream. Folk art exists outside the boundaries of established artistic convention. Since most aesthetically inclined individuals tend to seek formal training, biographical circumstance plays a much larger role in defining folk art than it does in mainstream art, for it is circumstance that determines whether an artist will or will not be able to obtain training. In nineteenth-century America, the prevailing bio-

paintings for inclusion in a private viewing at the Museum of Modern Art. However, this exhibition, which was open only to Museum members, had no immediate impact.

Finally, in 1940, Caldor stopped at the Galerie St. Etienne. Recently founded by Otto Kallir, a Viennese emigré, the Galerie St. Etienne specialized in modern Austrian masters such as Gustav Klimt, Oskar Kokoschka, and Egon Schiele. But Kallir, like many of the pioneers who championed modernism in the pivotal decades between the two world wars, was also interested in the work of self-taught painters. In Europe, this trend had been established when Picasso "adopted" the painting toll collector Henri Rousseau, and was furthered by the published writings of the Russian-born Expressionist Wassily Kandinsky. Essentially, these artists and their various followers believed that the work of self-taught artists was purer and more original than that of trained painters. In tandem with a concerted effort to renounce academic tradition, the contemporary avant-garde looked to the example of those who, for whatever reason, had been denied formal training.

This passion for the "naive" or "primitive," which originated in Europe before World War I, first took root in America after that war. Initiated, here as in Europe, by artists, the hunt for art untrammeled by formal con-

graphical circumstance was geography: Physical distance from academic institutions alone was sufficient to create a native class of folk painters. As the cultural climate improved, the prevailing circumstance separating folk artists from the norm became economic: Moses, Kane, Pippin, Hirshfield, and others of their generation simply could not afford the luxury of studying art. More recently, as mass communications have created a virtually unavoidable common visual environment, folk art has largely been defined by psycho-social circumstances. The so-called outsider artists who became popular in the 1980s tend to be severely marginalized, frequently institutionalized, or homeless.

What happened to Grandma Moses remains unequalled in the annals of folk art. To put it bluntly, she failed to remain in her place. The writer Roger Shattuck characterized Henri Rousseau as "an object lesson for modern art." In truth, all folk art has functioned as a kind of convenient object lesson, a place where mainstream artists could go to recharge their creative batteries. Over the course of this century, members of the avant-garde have regularly dipped into various aspects of folk iconography, reinterpreting "primitive" stylistic tropes in accordance with their own ends. Not only did this strategy often help trained artists arrive at new and innovative pictorial solutions, but these artists could proudly point to parallels between their work and that of the self-taught as proof of their own aesthetic purity. What the avant-garde mainstream could not and did not do was accord the self-taught artist respect on his or her own terms. Much as they might love folk art, modern artists and art historians almost never granted self-taught artists parity.

In defiance of this pervasive prejudice, Grandma Moses became a superstar. She did not do so willfully or suddenly, but she did so nonetheless. Her talk at Gimbels in 1940 brought a burst of publicity, and Moses was soon something of a local celebrity, but her renown was confined to New York State. She exhibited at a number of Upstate venues and began to be besieged by vacationers seeking artistic souvenirs. For some years, Moses resisted signing a formal contract with Kallir, believing she could manage matters herself. Finally, in 1944, frustrated by the seasonal nature of her tourist-oriented business and by difficulties in collecting payment from some of her customers, she agreed to be represented exclusively by the Galerie St. Etienne and the American British Art Center, whose director, Ala Story, had also become a steady buyer of Moses' work.

The events that established Moses as a national and then international celebrity followed in quick succession. Kallir and Story immediately launched a series of traveling exhibitions that would, over the ensuing two decades, bring Moses' work to more than thirty American states and ten European nations. In 1946, Kallir edited the first monograph on the artist, *Grandma Moses: American Primitive,* and oversaw the licensing of the first Moses Christmas cards. Both projects proved so successful that the following year the book was reprinted and the greeting card license taken over by Hallmark. In 1949, Moses traveled to Washington to receive a special award from President Truman (Fig. 8). The next year, a documentary film on her life, photographed by Erica Anderson, directed by Jerome Hill, and with narration by Archibald MacLeish, was nominated for an Academy Award. Her autobiography, *My Life's History,* was published in 1952.

The dawning age of mass communications gave the public unprece-

dented access to Grandma Moses and her work. In addition to traveling exhibitions, books, and greeting cards, people could enjoy posters and even mural-sized reproductions, China plates, drapery fabrics, and a number of other licensed Moses products. By live-remote broadcast—then a technological marvel—Moses' voice was beamed out from her home in Eagle Bridge to the larger world. A rare use of color television was made to show Moses' paintings when she was interviewed by Edward R. Murrow in 1955. And Lillian Gish portrayed the artist in what may well have been the first televised "docudrama."

The rags-to-riches saga of the elderly painter captured the American imagination. Facing the harsh realities of the cold-war era, the public took heart in a real-life tale that seemed to prove the old adage, "It's never too late." The media seemingly never tired of repeating Moses' fairy-tale story. In 1953, she was featured on the cover of *Time* magazine; in 1960, *Life* sent noted photographer Cornell Capa to do a cover story on the artist's 100th birthday. That birthday—declared "Grandma Moses Day" by New York's governor, Nelson Rockefeller—was celebrated almost like a holiday in the nation's press. The fanfare was repeated the following year, when Moses turned 101. Everyone rejoiced at the artist's longevity. Grandma Moses passed away several months after her 101st birthday, on December 13, 1961.

While Moses would never have achieved a comparable level of success without Otto Kallir's careful management, the artist's spectacular late-life career was in large measure due to circumstances beyond the control of any one individual. Essentially, the Moses phenomenon consisted of

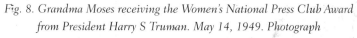

Fig. 8. Grandma Moses receiving the Women's National Press Club Award from President Harry S Truman. May 14, 1949. Photograph

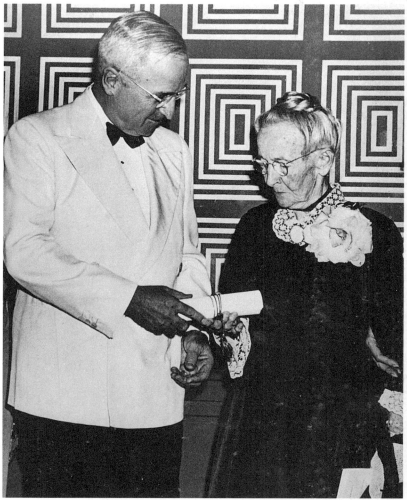

three interwoven strands: the artist's downhome story, her art, and the peculiar exigencies of the early cold-war years. The importance of Moses' biography should neither be exaggerated nor underestimated. Starting with the Gimbels talk, people were charmed—even thrilled—to note that the artist was as simple and unaffected as her paintings. Both in her person and in her art, she evoked the vanished nineteenth century, a seemingly calmer and more innocent time.

Yet biography alone was not everything. Other old codgers could, after all, paint—and in fact did so, once Moses got the ball rolling. It seemed hardly a week went by without the discovery of a new "Grandpa Smith" or "Auntie Jones." Yet none ever had the impact that Moses did. And although Moses' media appearances were, for their day, sensational, they were relatively infrequent by modern standards. She spent almost her entire twenty-one-year career undisturbed in Eagle Bridge. By and large, what the admiring public saw was not the artist, but her art.

The famous Moses style has been so often imitated that it has become difficult for people today to see the real thing with fresh eyes. Many assume that the appeal of Moses' work rests on a nostalgic evocation of nineteenth-century rural life, but the paintings themselves tell a rather different story. Moses' figural and scenic vignettes are so nearly abstract that they are capable of evoking the past in only the most symbolic sense. Her landscapes, however, are portrayed with an accuracy that is very much of the present. There is thus a link between the past and the present in Moses' work that seems to secure the future. The message is that some things—the scent of summer on the winds of spring, the bite of the first snow in November—do not change. Moses inspired not nostalgic longing, but hope. Hers was a message that postwar America desperately needed to hear.

Moses' extreme popularity inevitably separated her from the ranks of other folk painters (such as Kane or Pippin) and their more circumscribed audience. Fame also separated her from the art-world elite that had championed folk art in its more obscure moments. Moses' comparatively realistic style was juxtaposed—both by her supporters and by her detractors—with the Abstract Expressionist movement concurrently in ascendancy. After a controversial 1943 retrospective of the self-taught painter Morris Hirshfield nearly cost him his job, MOMA director Alfred Barr threw his lot in with the abstractionists and abandoned his support of folk art. The rest of the art-world elite followed suit.

For a number of decades, twentieth-century folk art went into a kind of eclipse. Some of folk art's staunchest supporters—including a significant faction at New York's Museum of American Folk Art—seriously maintained that folk art had died with the nineteenth century. Legitimate self-taught art, it was said, could not survive in a technological age. Folklorists and art historians then proceeded to split hairs over terminology,

with the folklorists contending that true folk art has a communal, utilitarian orientation that precludes the inclusion of *any* sort of autonomous painting. Moses, Kane, Pippin, and their like were defined out of existence.

Of course, one of the nice things about folk artists is that the real ones pay absolutely no attention to such theoretical squabbling. They simply go about their business, painting as they see fit. It was perhaps inevitable that mainstream critics would one day return to looking at such ad hoc artistic creations, which in truth never ceased to exist. Self-taught art has always stood as a powerful antidote to academic orthodoxy. And, as formalist abstraction itself acquired the rigid veneer of academic orthodoxy over the course of the postwar decades, folk art's appeal once again began to rise. The present boom in folk or "outsider" art has been furthered by the trend toward multiculturalism, which gives special attention to artists of diverse ethnic backgrounds. Just as Moses once represented a popular alternative to the arcane doings of the Abstract Expressionists, today's "outsiders" are hailed for their relative accessibility. Elitism is momentarily on the out, populism is back in.

Curiously, none of this has had much effect on the reputation of Grandma Moses. The presently voguish "outsider" work is, after all, very different from hers. Living lives far more emotionally or intellectually marginalized than Moses', "outsiders" are often inspired by extremely idiosyncratic personal visions. Few "outsiders" see themselves as artists in the sense that Moses did, or learn or develop consciously in the manner that she and her generation of folk artists did. Thus, though Moses remains tied to the counter-tradition of "the other" that has always favored self-taught art, she has no place among the current crop of "outsiders."

To understand Grandma Moses in context, then, one must return to her time and place. Were the circumstance of her fame to be removed, she would fit most comfortably with the other folk painters of that period, such as John Kane, Horace Pippin, and Morris Hirshfield. Fame is a strange commodity, and it is sometimes difficult to determine whether it is due more to luck or merit. Above all, perhaps, Moses' posthumous reputation has suffered from the fact that she was famous at a time when fame was considered unseemly for an artist—before Andy Warhol decreed that all of us would be entitled to our fifteen minutes.

Nonetheless, it is evident that Grandma Moses' fame endured far longer than fifteen minutes. From the first Galerie St. Etienne show in 1940 until her death in 1961, she enjoyed a career that was as lengthy and rich as that of many a younger artist. And while the cult of celebrity has naturally diminished since her death, her work has endured. Today, over fifty years after Moses first burst on the scene, it may safely be said that in her case, fame and greatness were one.

GRANDMA MOSES

25 Masterworks

Plate 1

CATCHING THE THANKSGIVING TURKEY

1943. Oil on pressed wood, 18½ x 24¼" (47 x 61.6 cm). Signed, lower right. Private collection. Kallir 260

P articularly in the early years of her career, Moses frequently chose subjects that were staples of nineteenth- and early twentieth-century illustration. Catching the turkey—part of the annual Thanksgiving ritual—was one such theme that Moses painted numerous times (see Fig. 9). Though she often repeated subjects, no two compositions were ever alike.

For her first monograph, *Grandma Moses: American Primitive,* the artist was asked to write commentary for forty favorite paintings. Of *Catching the Thanksgiving Turkey,* she wrote:

Why do we think we must have turkey for thankgiven.

Just becaus our Forefathers did, they had it becaus turkeys were plentyfull, and they did not have other kinds of meat,

now we have abundance of other kinds of luxuries,

Poor Turkey, He has but one life to give to his country,

The spelling and punctuation in Moses' text, which was printed in a facsimile of her handwriting, were not altered for publication. This caused the artist grave embarrassment, as did the book's title. "One of the neighbors asked if it was so that I could not read or write, being a primitive," she noted in disgust. When Moses' autobiography was published some years later, the spelling and grammar were corrected in deference to her wishes, and the word "primitive" was dropped.

Fig. 9. Thanksgiving Turkey. 1943. Oil on pressed wood, 15⅛ x 19⅛" (38.2 x 48.5 cm). The Metropolitan Museum of Art, New York; Bequest of Mary Stillman Harkness. Kallir 293

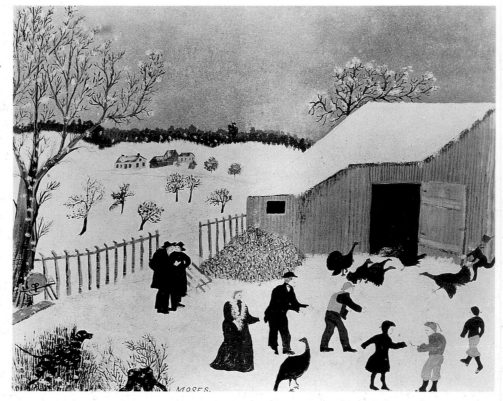

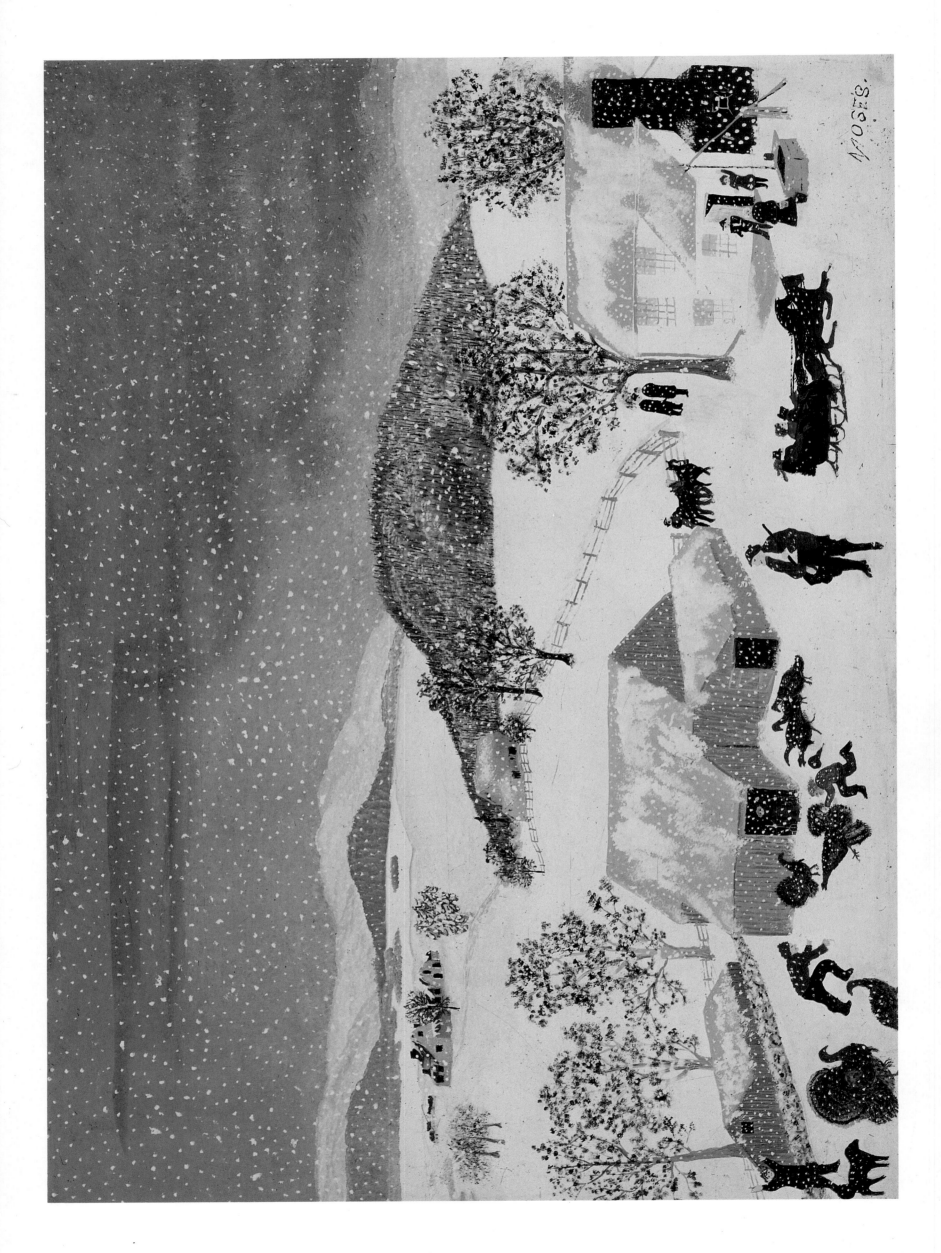

Plate 2

THE BURNING OF TROY IN 1862

1943. Oil on pressed wood, 18⅞ x 29⅞" (47.7 x 75.8 cm). Signed, lower
right. Seiji Togo Memorial, Yasuda Kasai Museum of Art, Tokyo. Kallir 298

Troy, which lies across the Hudson River from Albany, New York,
was the largest city near Grandma Moses' home in Eagle Bridge.
Surviving documents suggest that, for a brief period before she married,
the future artist did factory work in Troy.

A massive fire in Troy two years after Moses' birth clearly figured
prominently in local lore. Moses cut out and saved a commemorative
news clipping (Fig. 10), published in 1939, and used it as the basis for a
series of paintings. The artist's pencil notations on the clipping indicate
how she proposed to modify the vignette. *The Burning of Troy in 1862,*
the fifth version she did of the subject, is already quite far removed from
the clipping.

Conventional illustration tends to focus on foreground or background,
but seldom on both at once. Combining these two views was one
hallmark of the "Grandma Moses" style. Thus, in *The Burning of Troy*
Moses has considerably expanded the scene beyond the burning bridge,
including more foreground as well as a detailed rendering of the city in
the background.

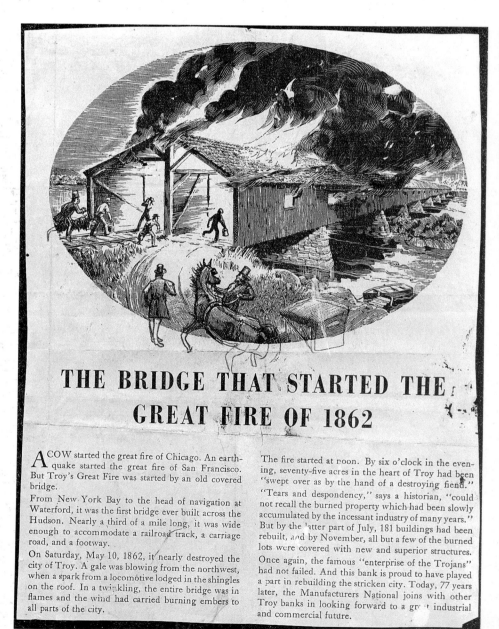

*Fig. 10. Newspaper clipping
of 1939 about the Great Fire
of 1862*

THE BRIDGE THAT STARTED THE GREAT FIRE OF 1862

A COW started the great fire of Chicago. An earthquake started the great fire of San Francisco. But Troy's Great Fire was started by an old covered bridge.

From New York Bay to the head of navigation at Waterford, it was the first bridge ever built across the Hudson. Nearly a third of a mile long, it was wide enough to accommodate a railroad track, a carriage road, and a footway.

On Saturday, May 10, 1862, it nearly destroyed the city of Troy. A gale was blowing from the northwest, when a spark from a locomotive lodged in the shingles on the roof. In a twinkling, the entire bridge was in flames and the wind had carried burning embers to all parts of the city.

The fire started at noon. By six o'clock in the evening, seventy-five acres in the heart of Troy had been "swept over as by the hand of a destroying fiend." "Tears and despondency," says a historian, "could not recall the burned property which had been slowly accumulated by the incessant industry of many years." But by the latter part of July, 181 buildings had been rebuilt, and by November, all but a few of the burned lots were covered with new and superior structures. Once again, the famous "enterprise of the Trojans" had not failed. And this bank is proud to have played a part in rebuilding the stricken city. Today, 77 years later, the Manufacturers National joins with other Troy banks in looking forward to a great industrial and commercial future.

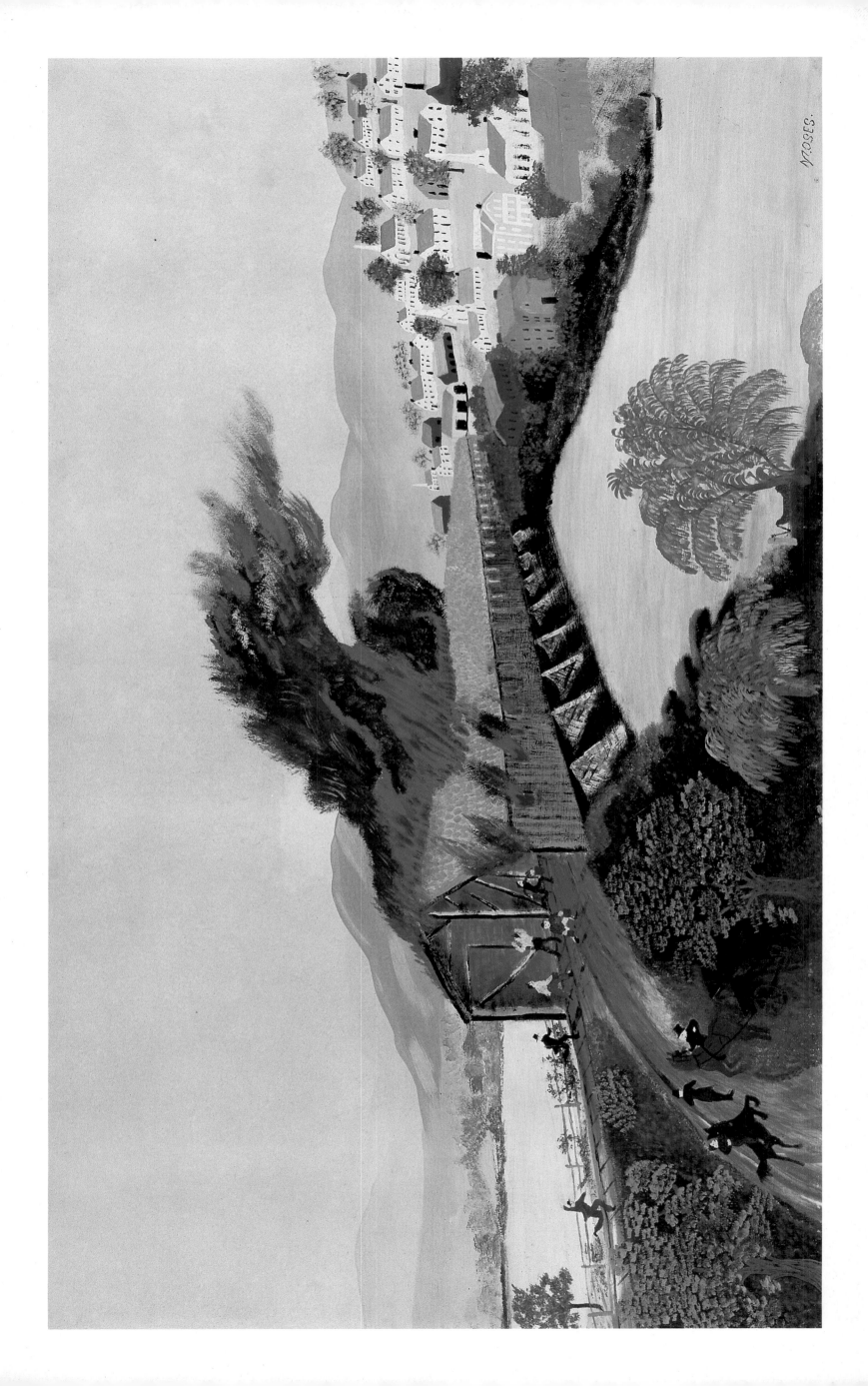

Plate 3

SUGARING OFF

1943. Oil on pressed wood, 23 x 27" (58.4 x 68.6 cm). Signed, lower
right. Private collection. Kallir 276

"Sugaring Off" was one of Grandma Moses' most popular themes,
and evidently also one of the artist's personal favorites. Like many
of her earliest subjects, it derived from popular illustration—in this case,
a well-known Currier & Ives lithograph (Fig. 11). Although Moses did at
the very start of her career sometimes copy compositions verbatim, she
never tried to duplicate this Currier & Ives print. Rather, from the start
she freely combined elements from her primary source with vignettes
from other sources and from her own imagination. Certain stock images
do tend to recur in the "Sugaring Off" paintings, however, among them
the burning cauldron, the mother pouring maple sugar on the snow
(where it would harden into instant candy), the men with buckets, and
the little "sugar house."

Sugaring Off dates from 1943, at the height of Grandma Moses' first
truly mature style. She had by this point in her career gained formidable
mastery of her medium. She was capable of rendering details with
pristine clarity and of handling extremely complex compositions. *Sugaring
Off* is notable for its vast assortment of disparate activities, arrayed in a
preternaturally broad landscape. This opening up of the landscape into an
almost square, quiltlike panoply of detail is one of the hallmarks of the
"Grandma Moses style." As she matured further, however, Moses would
revert to narrower horizontals (see Plates 23, 24, 25), which required
greater compression of detail.

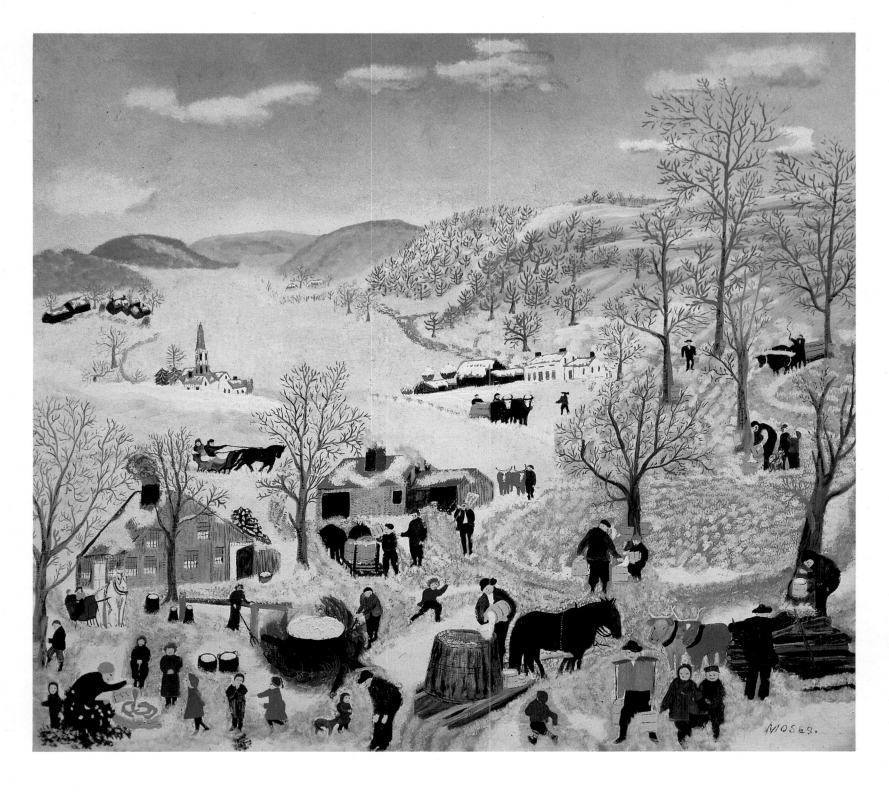

Fig. 11. Maple Sugaring—Early Spring in the Northern Woods. *1872. Lithograph published by Currier and Ives, New York. Museum of the City of New York; The Harry T. Peters Collection*

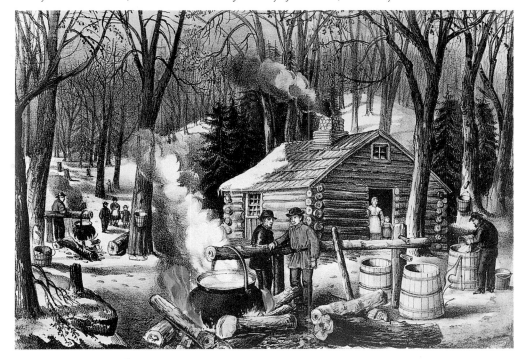

Plate 4
IN HARVEST TIME
1945. Oil on pressed wood, 18 x 28" (45.7 x 71.2 cm). Signed, lower left. Private collection. Kallir 537

As Grandma Moses gained in artistic confidence, she ventured into more complex and original compositions. Nevertheless, she still had recourse to a great trove of printed source material. All her life she collected clippings of images that appealed to her, until finally she had several thousand: dozens of farm animals, implements, buildings, and people performing a variety of tasks. These clippings covered all the activities and subjects she might conceivably want to paint, and in a selection of different sizes.

Often Moses would sort through her clippings, in the process gaining ideas for paintings she might like to tackle. Then she would select the appropriate clippings and array them on the pressed wood panel that was her preferred support. By rearranging the clippings on the panel, she eventually came up with a general composition. Though Moses had never studied formal perspective, she knew in a vague way that objects in the foreground should be larger than those in the background. The strange discrepancies in scale that one sometimes finds in her work probably result from the clippings at hand when the composition was being planned.

Moses' next task was to transfer the images from the clippings to the pressed wood panel. This she did by tracing the outlines of the salient portions, possibly with carbon paper. Comparison of a clipping to its painted counterpart (Figs. 12 and 13) invariably reveals that Moses copied only the broadest contours. She was interested in reducing her vignettes to their abstract essentials, rather than in slavish duplication of the source image. All the illustrative detail of the original clippings was lost in the transfer process, as was any color. Many of the clippings were black-and-white to begin with, but in any case Moses always reinterpreted the color in accordance with the requirements of the painting.

By converting fairly prosaic illustrations into abstract distillations of form, Moses populated her paintings with a cast of symbolic characters. With narrative detail reduced to a bare minimum, her figures cannot evoke the past in any specific, documentary manner. Instead, they function as ciphers with whom every viewer can identify.

Moses created a paper-doll world, peopled not by real creatures but by symbols of real creatures. Thereby she demanded a role of the imagination similar to that found in child's play. Her audience is invited to finish the story, cued by details of place and occupation. The sphere of action is thus removed from a personal to a universal plane.

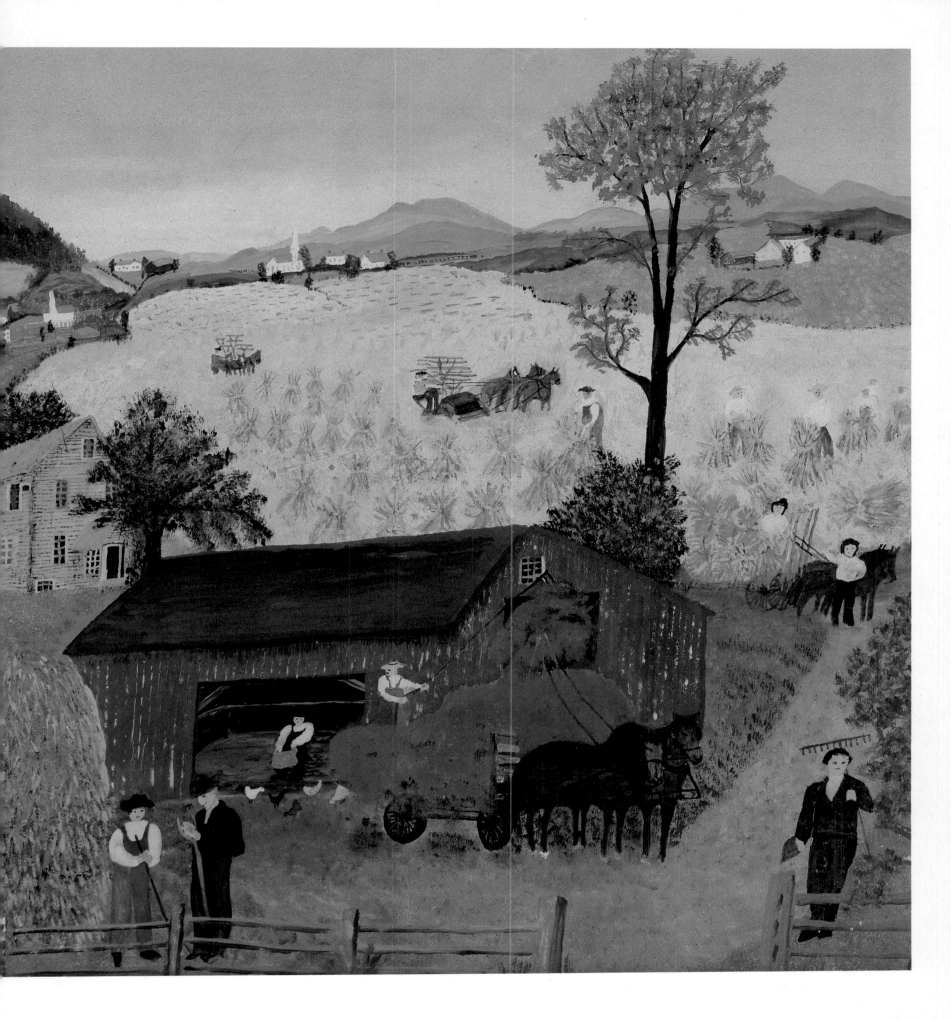

*Fig. 12. Halftone newspaper illustration
with Moses' pencil outlining.*
3½ x 5¾" (9 x 14.6 cm)

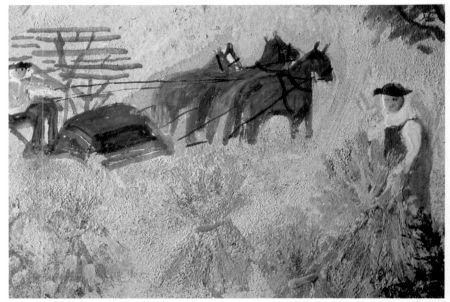

Fig 13. In Harvest Time (*detail*)

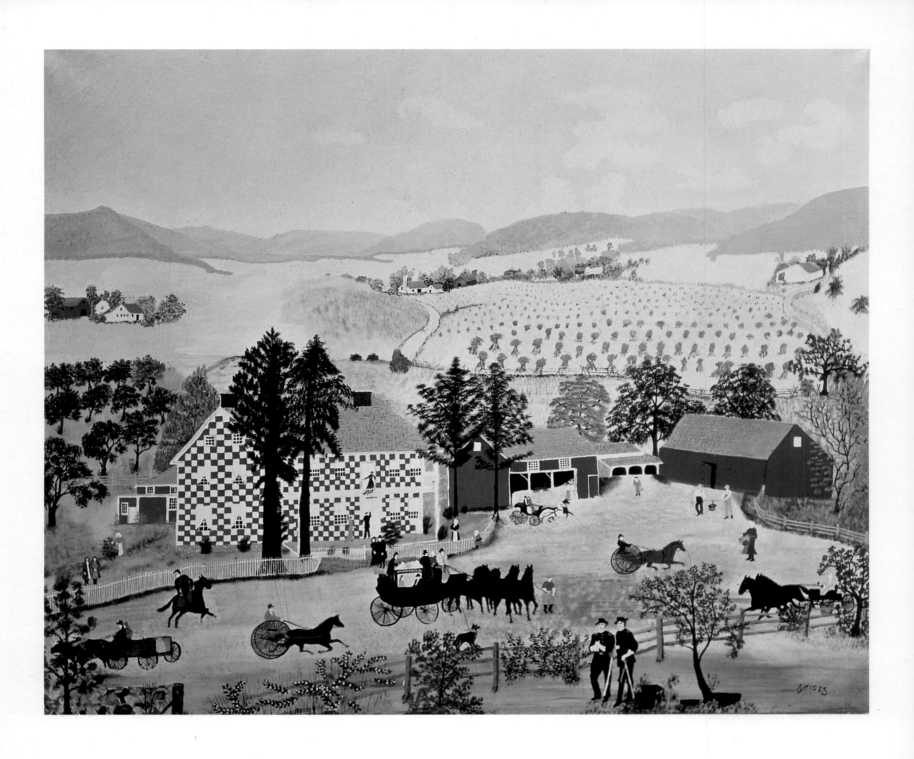

Plate 5
CHECKERED HOUSE
1943. Oil on pressed wood, 36 x 45" (91.5 x 114.3 cm). Signed, lower right. IBM Corporation, Armonk, New York. Kallir 317

Like the Troy fire (Plate 2), the Checkered House was a local legend. Situated along the Cambridge Turnpike, it was an inn where stagecoach drivers had changed horses as far back as the eighteenth century. During the Revolutionary War, the inn served as General Baum's headquarters and field hospital. Its checkerboard front made the house a distinctive landmark that was remembered long after it burned in 1907.

Moses painted a number of versions of "Checkered House," in both winter and summer. When asked how she managed to come up with a new composition each time, she said she imagined the scene as if she were looking at it through a window. By then shifting her viewpoint slightly, she could cause the elements to fall into place differently.

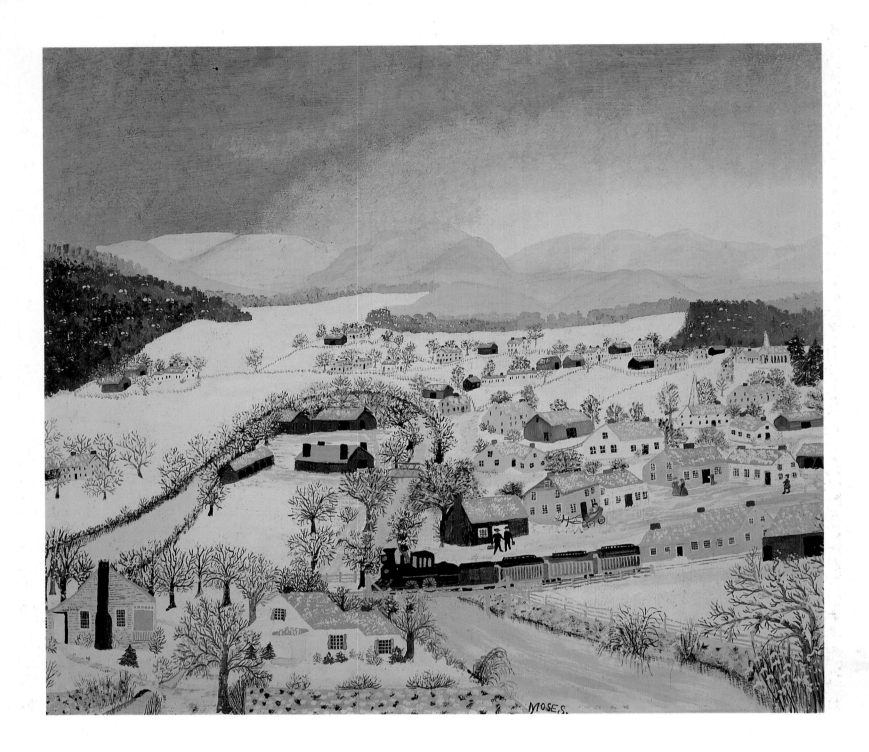

Plate 6

HOOSICK FALLS, NEW YORK, IN WINTER

1944. Oil on pressed wood, 19¾ x 23¾ (50.1 x 60.3 cm). Signed, lower
center. The Phillips Collection, Washington, D.C. Kallir 425

The Village of Hoosick Falls will always have a key place in the
biography of Grandma Moses. It was here that her paintings were
first discovered, sitting in Thomas' Drugstore window, and it is here that
the artist is buried.

For Moses herself, however, the importance of Hoosick Falls lay not in
its connection to her own career, but in the village's role in American
history. Today Hoosick Falls, the closest real town to the Moses
farmstead, is a sleepy hamlet, somewhat passed over by modern
economic development. However, until the Great Depression, it was a
bustling commercial center, its industrial potential bolstered by its
situation at the confluence of the Hoosick and Walloomsack Rivers.
Moses associated the area, hunting grounds of the Mohican Indian tribe,
with the tales of James Fenimore Cooper. "Some say Natty Bumpo sleeps
his sleep in an unknown grave in the village limits," she wrote.

Moses painted a number of versions of Hoosick Falls, showing the
village in various seasons. Most follow the winding path of the Hoosick
River, and may be based in part on old prints of the town. The bird's-eye
view—encompassing more than would be visible from any single human
vantage point—is, however, typical of Moses' unique approach.

19

Plate 7

EARLY SPRINGTIME ON THE FARM

1945. Oil on pressed wood, 16 x 25¾" (40.7 x 65.4 cm). Signed,
lower right. Private collection, courtesy Galerie St. Etienne, New York.
Kallir 500

The title *Early Springtime on the Farm* is an example of Moses' dry Yankee humor. The calendar may say it's spring, but in the North there is still plenty of snow on the ground.

Nonetheless, signs of a thaw are evident in the foreground of the painting, where a flock of geese waddles along on fresh turf. "These are the damp snow days," Moses wrote, "when we love to go to the woods and look for the first bloom of the trailing arbutus, which sometimes blooms beneath the snow, or gather the pussy willow. Those are the days of childhood."

Moses invariably recalled her childhood in idyllic terms:

*Those were my happy days, free from care or worry, helping mother . . .
sporting with my brothers, making rafts to float over the mill pond, roaming
the wild woods, gathering flowers, and building air castles.*

Yet the artist's autobiography is full of events that are far from blissful: the burning of her father's mill, storms so severe they almost wiped out the farm, and illnesses, today readily controllable, for which there was then no cure. Two of Moses' brothers and one sister did not live to adulthood. "We had to take the bitter with the sweet, always," she later wrote. "Mother was very matter-of-fact, and she said, 'As you are born, you must die,' and father took it that way too."

The tranquillity in Moses' art, then, does not come from denying unpleasant realities, but from making peace with them.

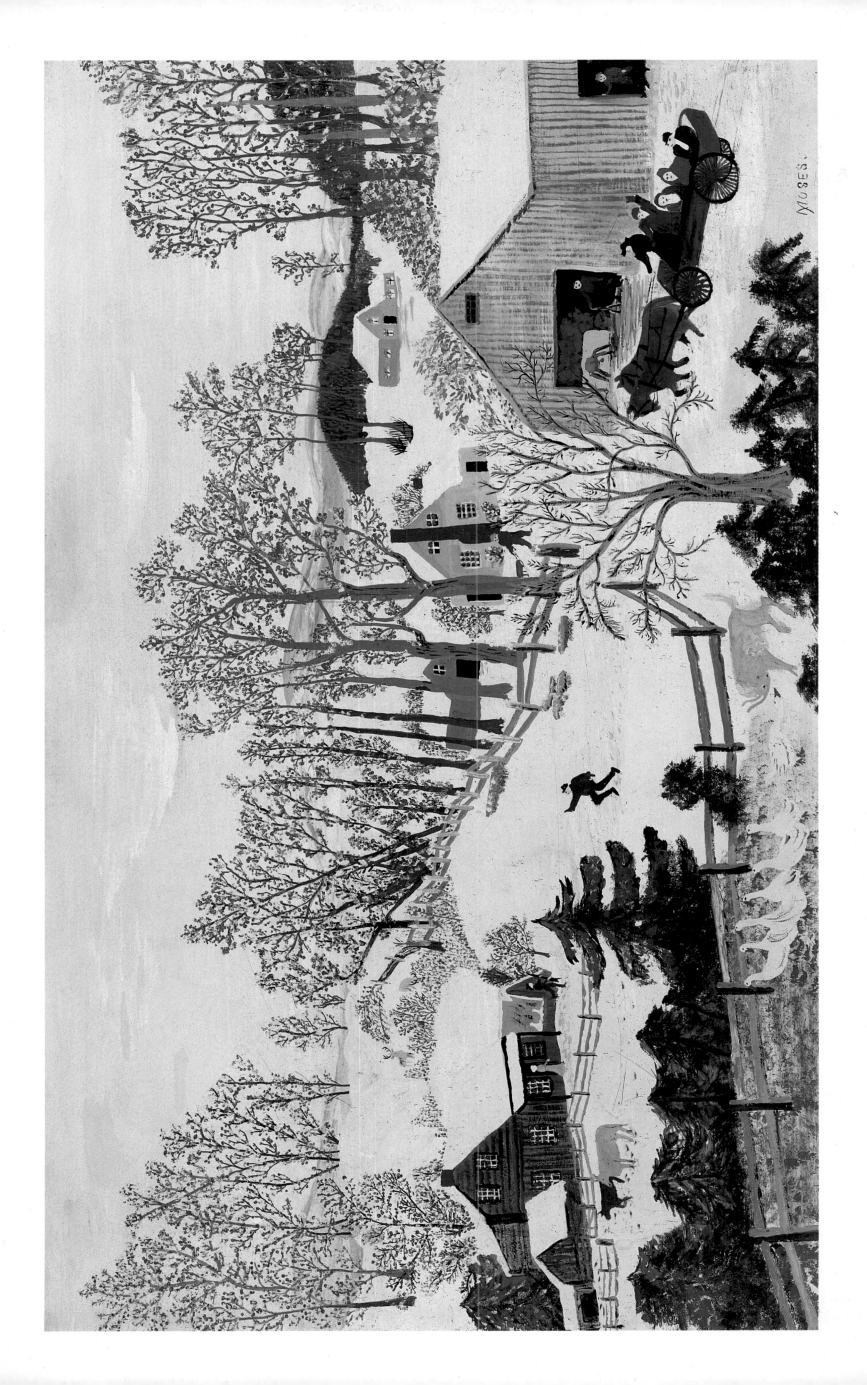

Plate 8
WASH DAY

1945. Oil on pressed wood, 17¾ x 23½" (45.1 x 59.7 cm). Signed, lower center. The Museum of Art, Rhode Island School of Design, Providence. Kallir 498

Many of Moses' earliest paintings had drawn on traditional American themes, such as "Catching the Thanksgiving Turkey" (Plate 1) or "Sugaring Off" (Plate 3). Moses chose these subjects because they reflected her personal experience, and it was this experience, as well as her keen observation of the surrounding landscape, that gave new life to these relatively dated images. As she grew more artistically confident, however, she began to craft paintings that were based more directly and completely on her own memories. *Wash Day* is such an image.

Moses recalled that the painting was inspired by a poem she had learned in school as a child. Some seventy years later, she could still recite it by heart:

Oh Monday was our washing day,
and while the clothes were drying,
a wind came whistling through the line
and set them all a-flying.
I saw the shirts and petticoats
go flying off like witches.
I lost (oh bitterly I wept),
I lost my Sunday breeches.
I saw them flying through the air,
alas too late to save them.
A hole was in their ample part,
as if an imp had worn them.

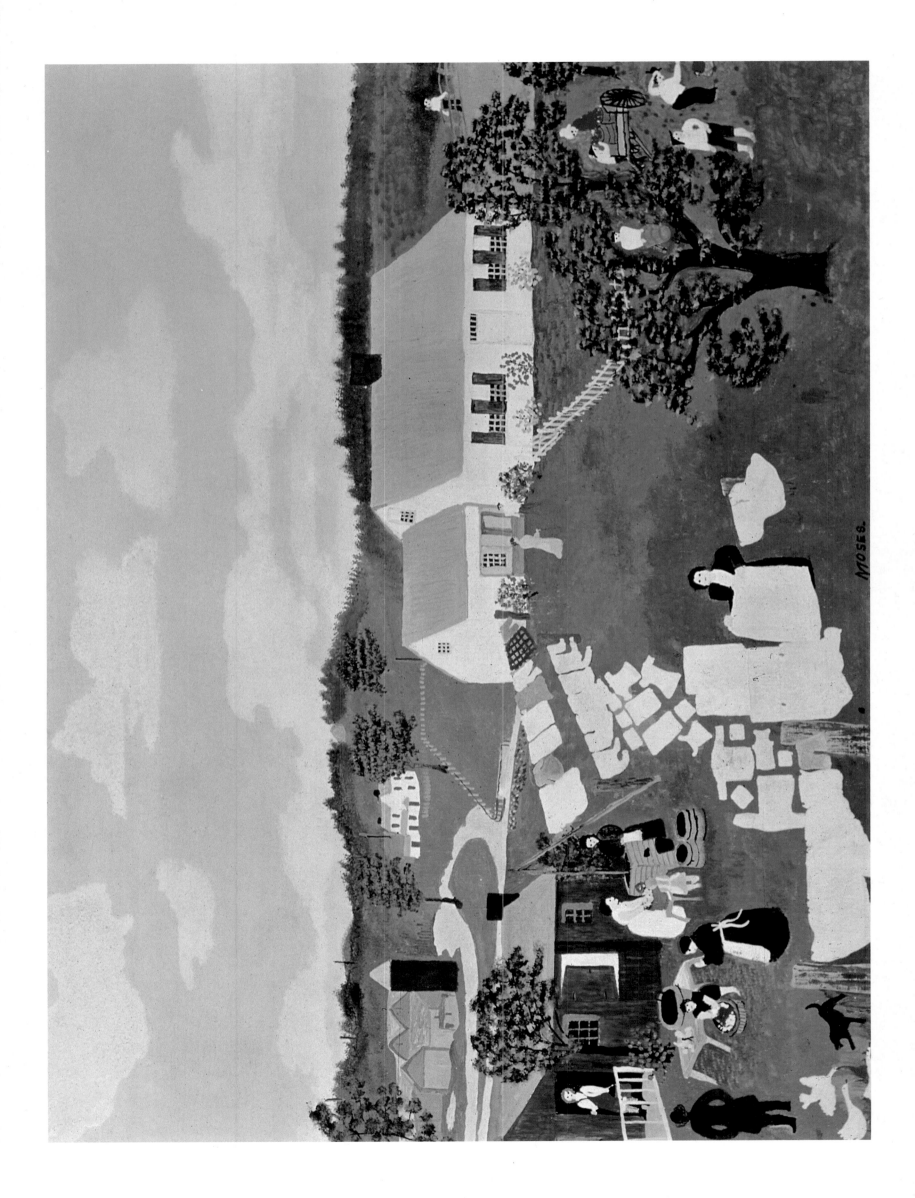

Plate 9

HOOSICK VALLEY (FROM THE WINDOW)

1946. Oil on pressed wood, 19½ x 22" (49.5 x 55.9 cm). Signed, lower right. Private collection. Kallir 611

If Moses took anecdotal vignettes from newspaper and magazine clippings (see Plates 2 and 4), her painting technique was largely derived from her experiences with embroidery.

Like all women born in the days when store-bought clothes were a rare luxury, Moses had learned to sew in early childhood. Her first sustained pictorial efforts were, perhaps as a result, undertaken not with paint but with yarn. Even after Moses gave up making these embroidered "worsted" pictures, she tended to treat paint like yarn.

Perhaps one of the most salient aspects of working with yarn is that—unlike paint—yarn makes it impossible to blend colors (see Fig. 14). In order to achieve subtle gradations of hue, multicolored strands must be placed side by side. This way of working translated into what some have characterized as Moses' impressionistic handling of paint. In *Hoosick Valley (From the Window),* varied tones of green and yellow are set next to one another to evoke the interplay between parched meadows and verdant hills.

Moses also used paint texture in a manner that mimicked embroidery. Fenceposts are "stitched" into place, blossoming trees appear to be rendered in little knots of thread (see Fig. 15). Moses established a series of textural gradations, from flat expanses and isolated blocks of color to more intricate, multicolored configurations. Certain details were deliberately executed in raised paint in order to set them off from the background (see Fig. 16). Many of Moses' paintings, when viewed up close, are actually composites of abstract forms.

Fig. 14. The Covered Bridge, 1818. *1939 or earlier. "Worsted" embroidery, 7½ x 9½" (19 x 24.2 cm). Formerly Louis J. Caldor. Kallir 13W*

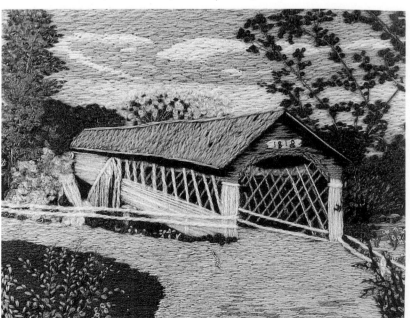

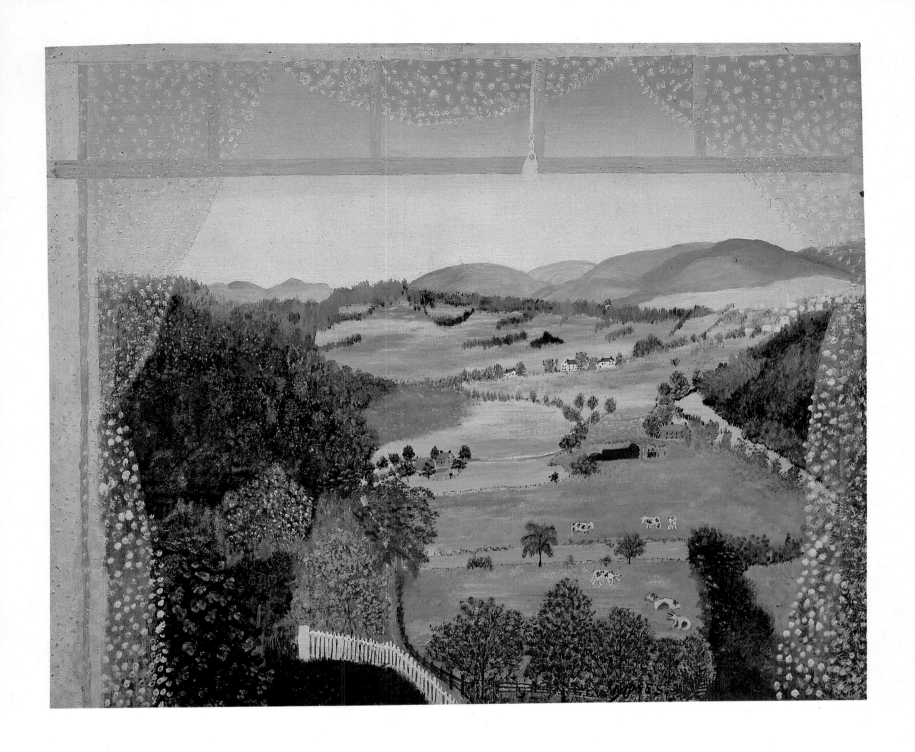

Fig. 15. Hoosick Valley (From the Window) *(detail)* Fig. 16. Hoosick Valley (From the Window) *(detail)*

Plate 10
CHRISTMAS AT HOME
1946. Oil on pressed wood, 18 x 23" (45.7 x 58.4 cm). Signed, lower right. Private collection, courtesy Galerie St. Etienne, New York. Kallir 586

Grandma Moses was closely associated with Christmas, in part because for many years Hallmark issued a best-selling line of Moses Christmas cards and in part because that holiday—with its combination of wintry cheer, evergreen trees, and joyful celebration—mirrors many of Moses' own favorite preoccupations.

Like all her work, Moses' Christmas paintings drew directly from her own experiences. She remembered her first Christmas thus:

Christmas morning . . . I scrambled out of bed. . . . Oh! how good things smelled. The living room and parlor were all decorated with evergreens around the doors and windows; everywhere was hemlock, mother's favorite evergreen. And the smell of hemlock and varnish has always been a favorite of mine ever since.

Then breakfast was ready, and while we were eating Lester spied a little China dog on the clock shelf. And it was marked William Lester Robertson, so it was his.

Then commenced the hunt for more toys. We found a small shepherd dog on the reservoir, marked Horace Greely Robertson.

But so far nothing for me.

Then I found another little short-legged dog marked Arthur M. Robertson.

Now as you know I felt pretty bad. And mother said it was too bad, as I had been a good girl, and for me to keep looking, which I did.

When the men came in for dinner, the hired man said he saw a lady looking out of the window at him behind the evergreens. And sure enough, there was Little Red Riding Hood, for Anna Mary Robertson.

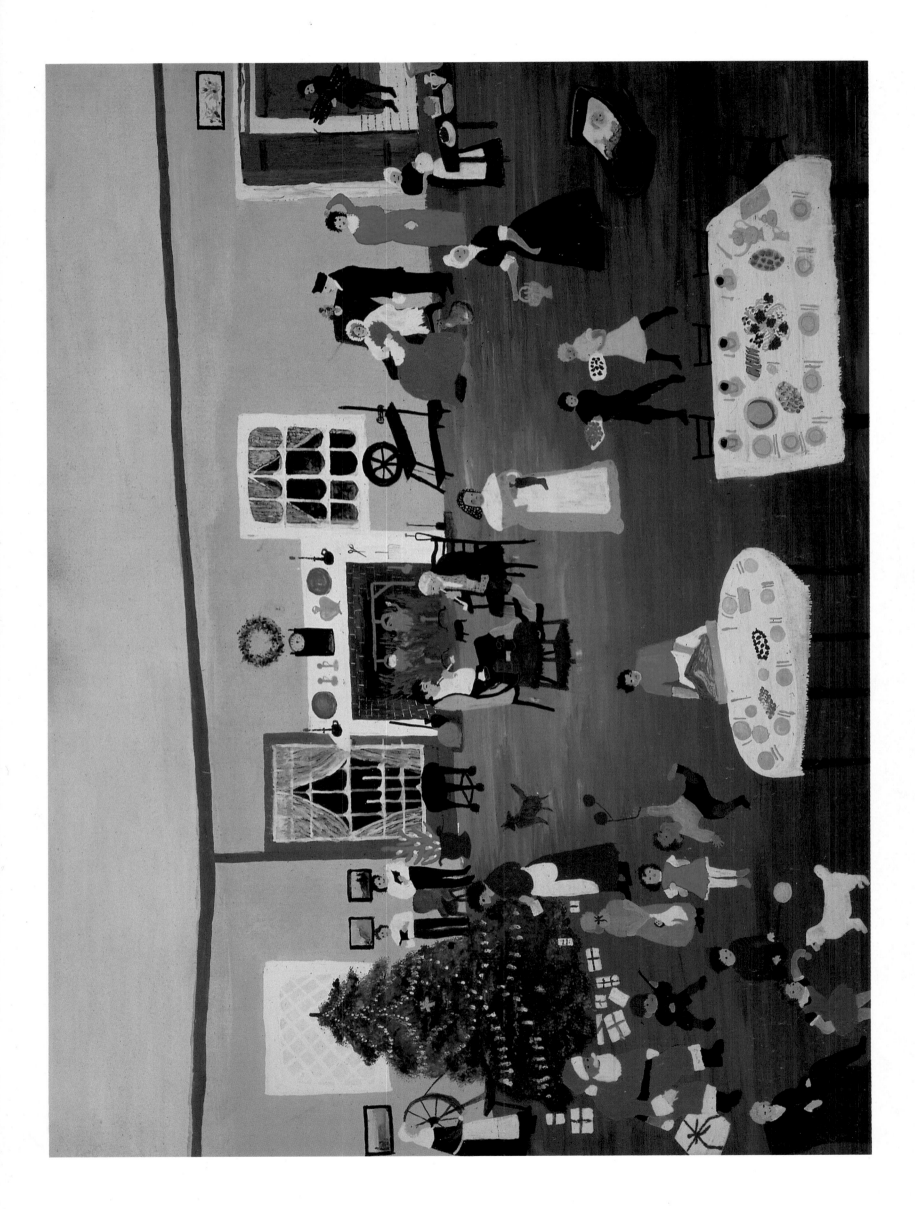

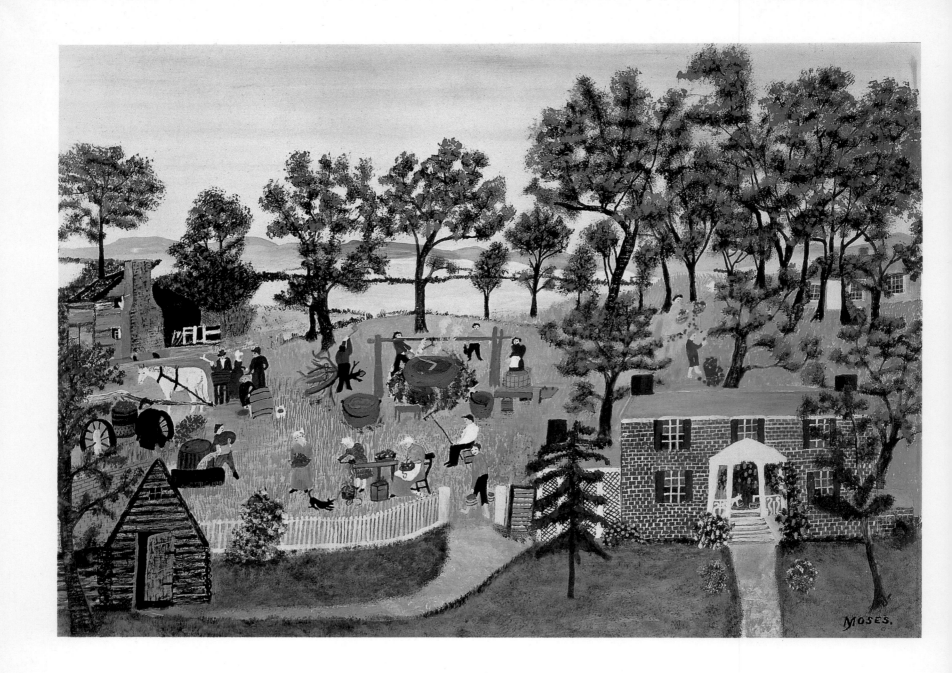

Plate 11
APPLE BUTTER MAKING
1947. Oil on pressed wood, 16½ x 23⅝" (41.9 x 59.3 cm). Signed, lower
right. Private collection. Kallir 653

Although many people think of apples as a New England commodity,
Apple Butter Making is actually among a handful of paintings based
on Moses' Virginia memories. The house in the picture is the Dudley
Place, one of several farms the Moses family occupied as tenants during
their years down South.

"Late summer was the time for apple butter making," Moses wrote in
her autobiography. "The apple butter was considered a necessity."

*To make apple butter, you take two barrels of sweet cider (you grind apples
and make sweet cider first), then you put them on in a big brass kettle over
a fire out in the orchard and start it to boiling. You want three barrels of
quartered apples, or snits, as they called them, with cores taken out, and
then you commence to feed those in, and stirring and keeping that stirrer
going. . . . Women folks would keep that going, feeding in all the apples
until evening. Then the young folks would come in to start stirring. They'd
have two—a boy and a girl—to take hold of the handle. They'd have a
regular frolic all night out in the orchard.*

Moses' personal recollections—parts of which read like recipes, others
like social history—were mirrored in the content of her painting.

28

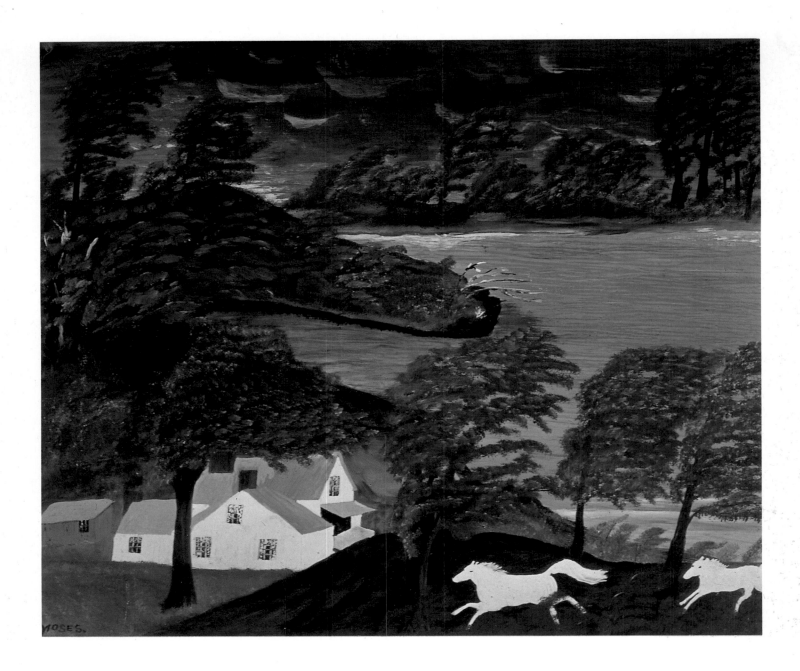

Plate 12

A STORM IS ON THE WATER NOW

1947. Oil on pressed wood, 16 x 20¼" (40.7 x 51.4 cm). Signed, lower
left. Santa Barbara Museum of Art, California; Gift of Margaret Mallory.
Kallir 666

Those who know Grandma Moses' paintings only from reproductions
often fail to realize how profoundly accurate were her representations
of the natural environment. Indeed, it is her precise evocations of the
rural landscape that bring her paintings to life and that to a large extent
account for their enduring appeal.

 This aspect of Moses' achievement is perhaps most readily
demonstrated by her storm scenes, for here the various forces and colors
of nature appear of necessity in exaggerated form. *A Storm Is on the Water
Now* is one of the artist's most dramatic pictures. Compared to *The
Thunderstorm* (Plate 15), it is a simple composition. However, by focusing
on the terror of the two white horses, Moses has distilled and highlighted
the impact of the raging torrent. A relatively limited palette further
heightens the emotional effect.

Plate 13

THE SPRING IN EVENING

1947. Oil on pressed wood, 27 x 21" (68.6 x 53.3 cm). Signed, lower left.
Private collection, courtesy Galerie St. Etienne, New York. Kallir 706

While Moses' way of piecing together compositions was partly dictated by her sense of abstract design, the arrangements were always subordinated to the requirements of the landscape. As a substitute for academic perspective (which she had never learned), she had recourse not just to a progressive scheme of diminishing sizes, but also to coloristic indicators of space. She was quick to note such qualities as the pale blue of distant hills, or the tonal gradations of the sky. She translated phenomena observed from nature into veils of color and layers of pigment.

The Spring in Evening is notable for the way in which Moses captured both time of year and time of day. The rawness of the freshly plowed earth (Fig. 18), the new growth on the hillside (Fig. 17), and the lambent pink of the sunset are all rendered with a sure feel for color and a striking verisimilitude. Variations in the physical and tonal density of the paint create a series of transitions between the artist's anecdotal vignettes and the more complex hues of the landscape. The bold silhouette of the horses and the houses are spare, formal essences embedded in a network of paint. It is, however, the natural landscape that brings the whole to life.

Fig. 17. The Spring in Evening *(detail)*

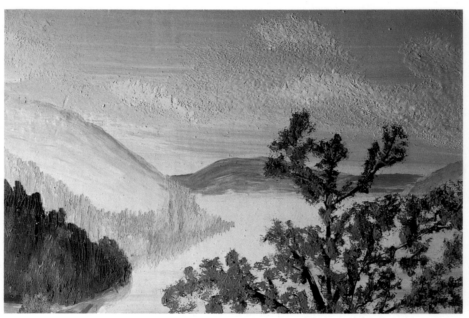

Fig. 18. The Spring in Evening *(detail)*

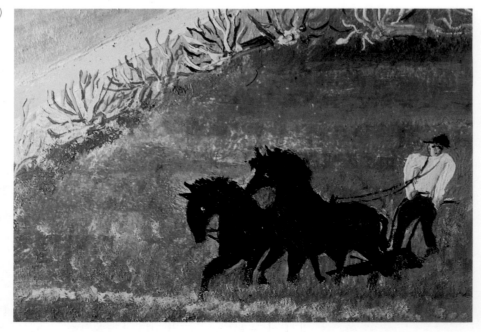

Plate 14
THE OLD OAKEN BUCKET

1947. Oil on pressed wood, 23½ x 27½" (59.7 x 69.9 cm).
Signed, lower left. Private collection. Kallir 669

"The Old Oaken Bucket" was one of Moses' most popular subjects in the early years of her career, before she signed her exclusive agreement with the Galerie St. Etienne. During the period when she herself dealt directly with customers, "Old Oaken Buckets" were much in demand. One can surmise that eventually Moses got sick of painting them, for the theme is much less common later in her life.

Like many of Moses' early themes, *The Old Oaken Bucket* combines local lore and personal experience. In 1877, young Anna Mary worked as a hired girl for an elderly woman, Mrs. David Burch. Mrs. Burch told Anna Mary that the well on her farm was the original well that had inspired the famous song, "The Old Oaken Bucket." Moses recounted the following story:

Back in the 18th century, [Mrs. Burch's] great-grandfather lived in this place. He had an older brother who in his boyhood days fell in love with one of his neighbor's daughters. But her parents did not want her to go with Paul Dennis, as he and his people were poor folks. Well, that made trouble, and the young folks would write letters to each other, and they used one of the apple trees for a post office, and would sly out at night and exchange mail. Then Paul went off for three years as a sailor, in those days one had to sign up for three years, and Paul was young and got very homesick, and wrote the verses of the "Old Oaken Bucket." Then, when the three years were up, he came back to Boston and gave them to Woodworth, who set them to music, and therefore claimed them.

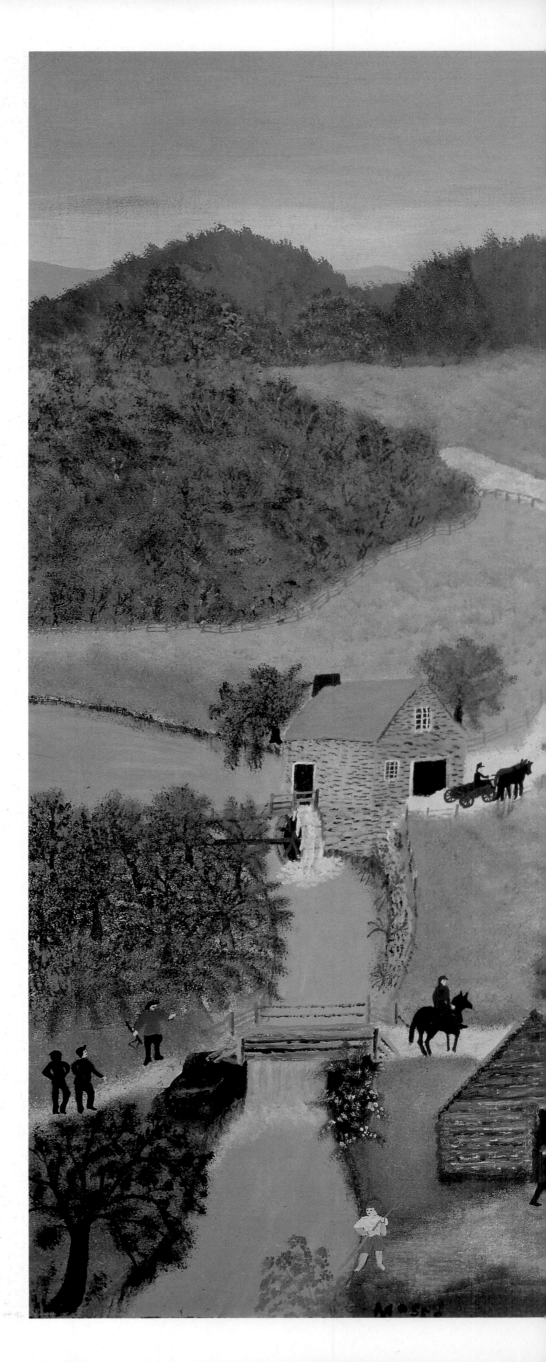

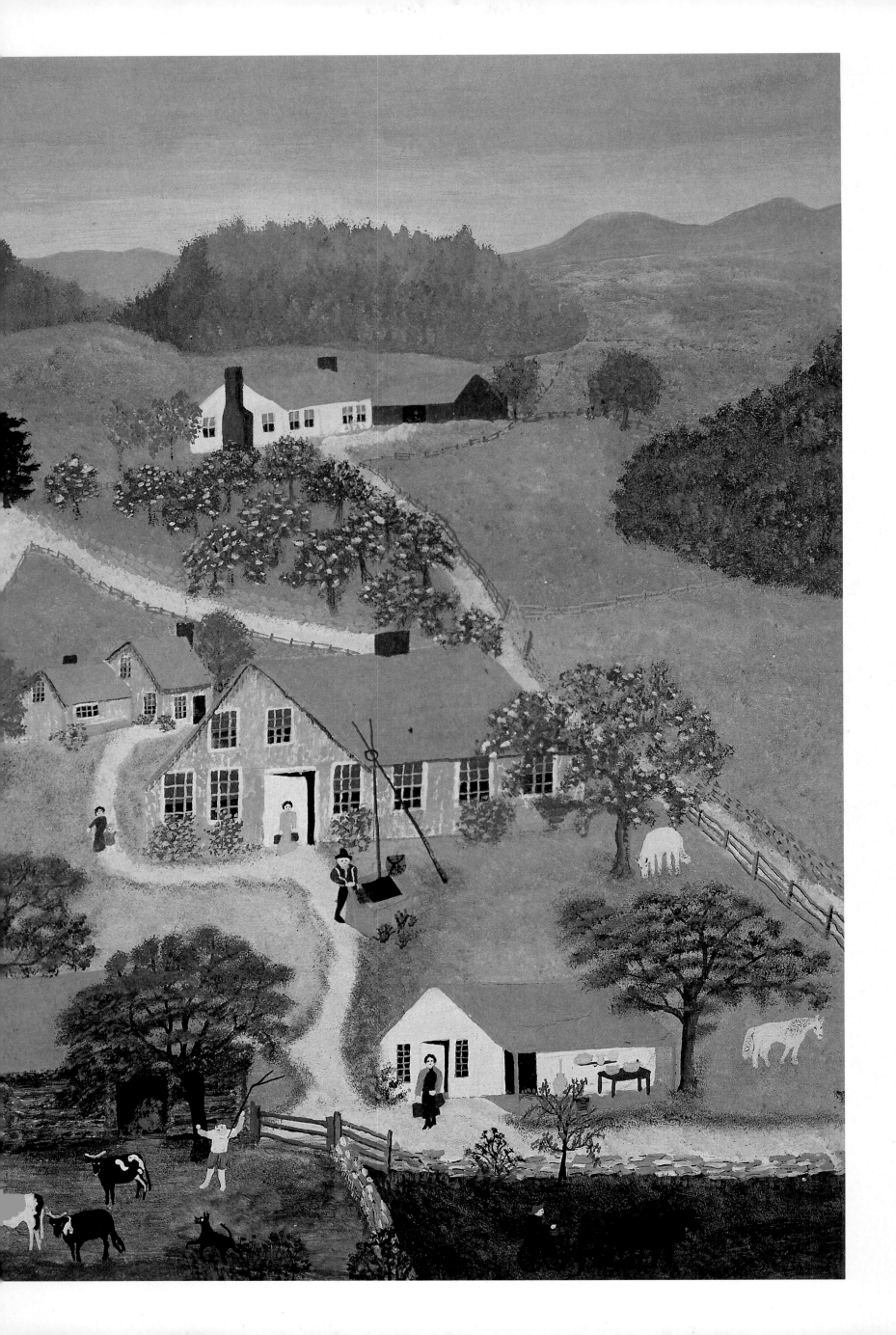

Plate 15

THE THUNDERSTORM

1948. Oil on pressed wood, 20¾ x 24¾" (52.7 x 62.8 cm). Signed, lower right. Private collection. Kallir 729

The Thunderstorm poignantly illustrates how Grandma Moses managed to combine intensely evocative renditions of natural phenomena with dramatic anecdotal detail.

There are several levels of action in *The Thunderstorm*. Fierce storm clouds are rapidly approaching over the mountains, and in the distance the trees have already begun to whip wildly in the wind (Fig. 20). The artist's deployment of color to represent these events is extraordinarily acute: The parched yellows of a late summer meadow, the varied greens of the trees, and the shifting colors of the sky before the advancing torrent are all keenly observed.

In the foreground, Moses presents the human reaction to the oncoming threat. There is a mad rush to get the hay into the barn and, at middle distance, a black horse bolts in terror (Fig. 21). The girl in the yellow dress is frozen in mid-run, while strangely, behind her to the left, two other children seem oblivious to the commotion (Fig. 19). The abstract forms used to render all the human and animal activity stand in sharp contrast to the impressionistic interplay of colors in the land-scape elements of the composition. This juxtaposition of abstraction and realism was one of the principal cornerstones of the "Grandma Moses style."

Fig. 19. The Thunderstorm (*detail*)

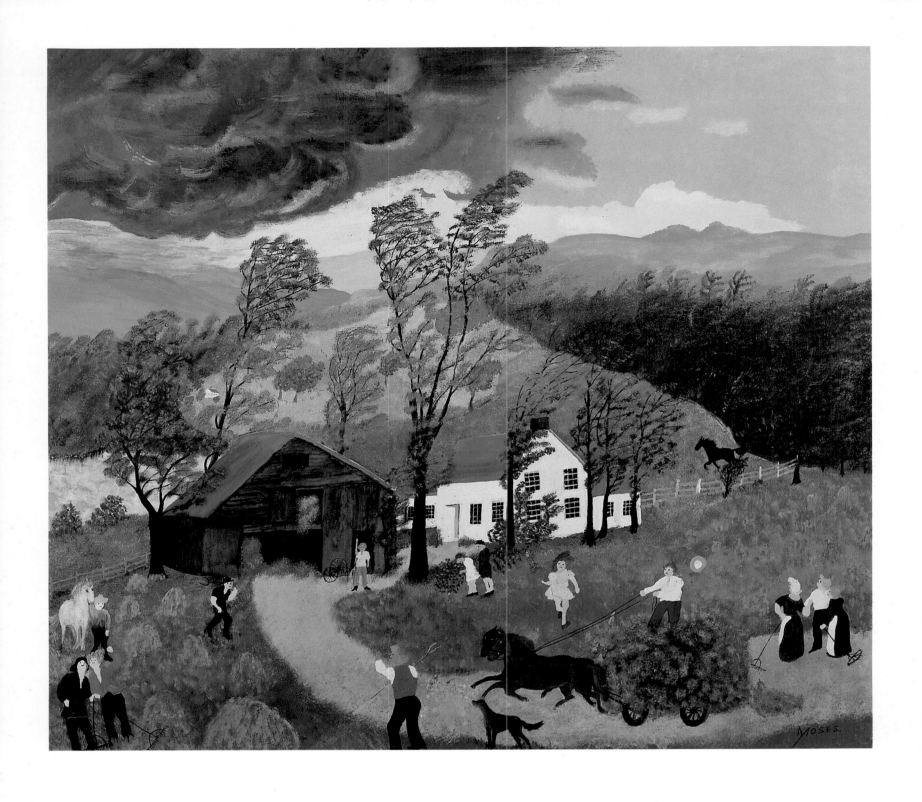

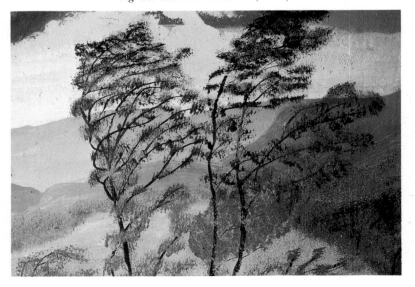

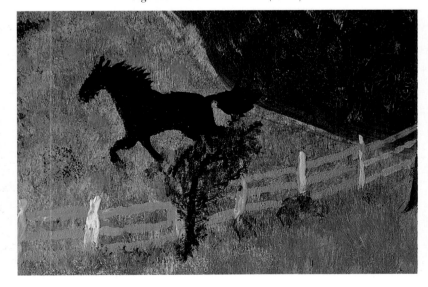

Fig. 20. The Thunderstorm (*detail*) *Fig. 21.* The Thunderstorm (*detail*)

Plate 16

A BEAUTIFUL WORLD

1948. Oil on pressed wood, 20 x 24" (50.8 x 61 cm). Private collection,
courtesy Galerie St. Etienne, New York. Kallir 787

As the title suggests, *A Beautiful World* represents Grandma Moses'
view of ideal harmony between humankind and nature.

"I like pretty things the best," Moses once told an interviewer. "What's
the use of painting a picture if it isn't something nice? So I think real
hard till I think of something real pretty, and then I paint it. I like to paint
old-timey things, historical landmarks of long ago, bridges, mills, and
hostelries, those old-time homes, there are a few left, and they are going
fast. I do them all from memory, most of them are daydreams, as it were."

So much twentieth-century painting has been difficult and pessimistic
that some have a tendency to dismiss Moses' vision as simplistic. In fact,
though, there has been much art throughout history that is accessible and
optimistic. All art is in some sense an affirmation of life—an offering of
the human spirit, however downtrodden, as proof that our thoughts and
feelings are ever precious and sometimes beautiful. This is the essence of
Grandma Moses' genius.

Fig. 22. A Beautiful World (*detail*)

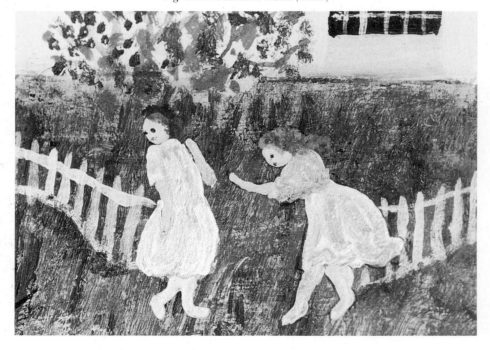

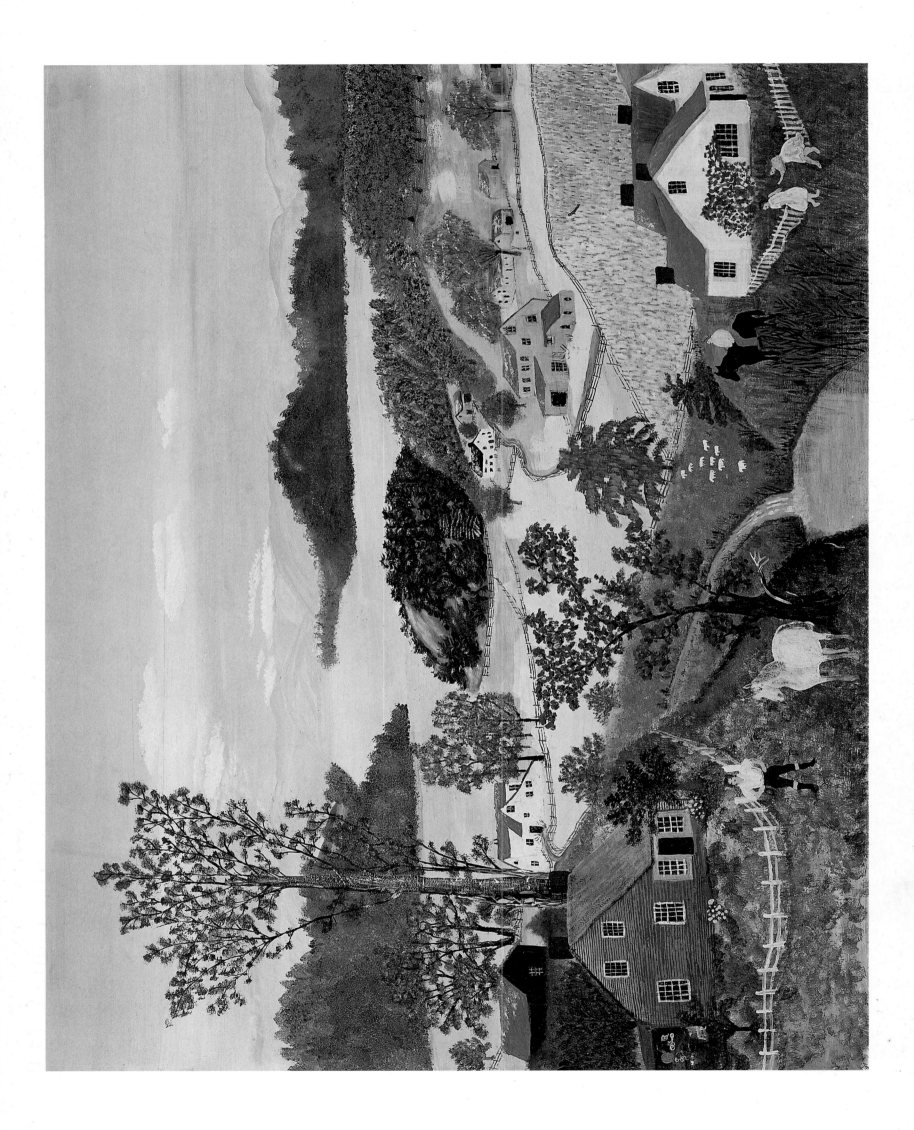

THE QUILTING BEE

1950. Oil on pressed wood, 20 x 24" (50.8 x 61 cm). Signed, lower right. Private collection. Kallir 883

Moses was basically a landscape painter, but certain memories and themes demanded an indoor setting. She herself knew this, and some of her patrons encouraged her to expand her repertoire to include interiors. The subject, however, did not come easily to her.

"I tried that interior but did not like it, so I erased it," she noted on one occasion. "That don't [sic] seem to be in my line. I like to paint something that leads me on and on into the unknown, something that I want to see away on beyond. Well, maybe I try again."

Despite her difficulties with the subject, Moses did paint a number of striking interiors (see also Plate 10). Without the landscape to anchor the scene and provide an element of realism, her interiors rely almost wholly on the artist's command of abstract form and patterning. These qualities are used to maximum advantage in *The Quilting Bee,* wherein the colors and forms of the large quilt and the elaborate table setting play off neatly against the bright clothing of the numerous bustling characters. Still, Moses could not resist adding a bit of nature beyond the tall, uncurtained windows.

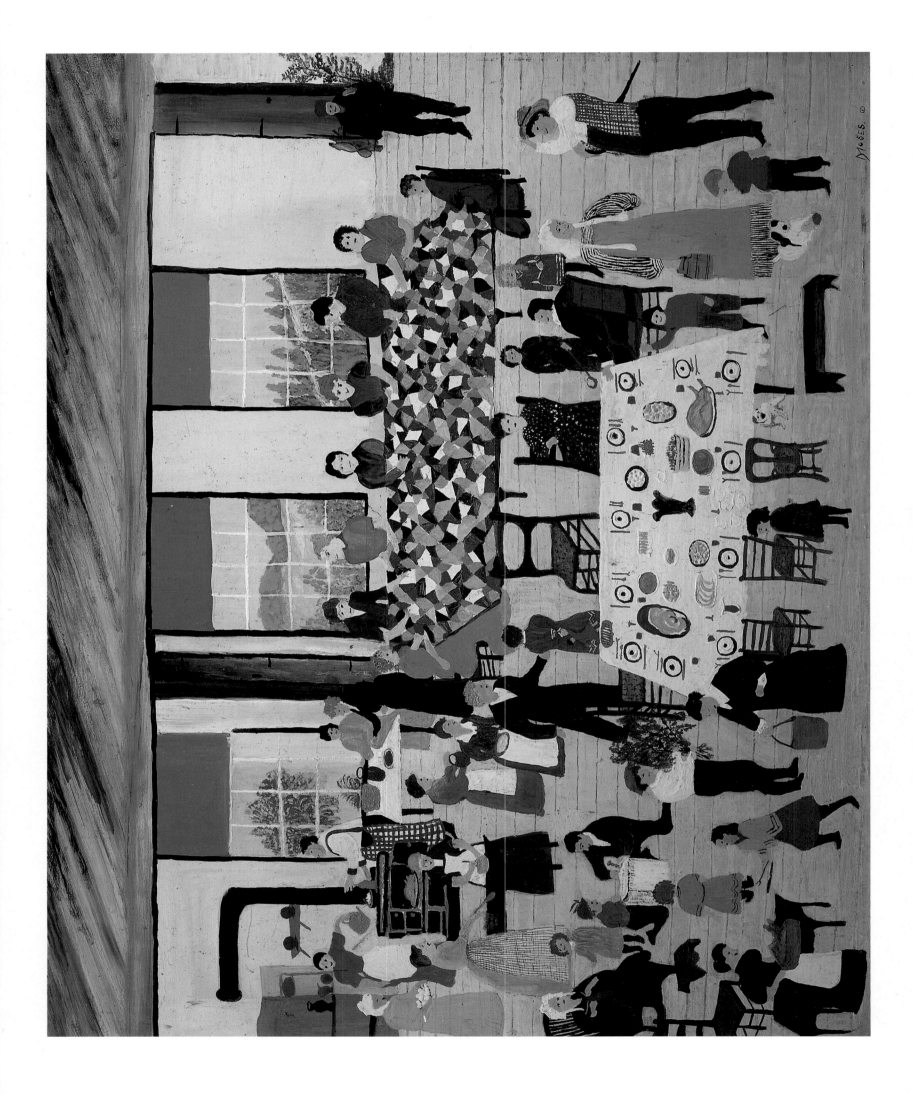

Plate 18
MOVING DAY ON THE FARM
1951. Oil on pressed wood, 17 x 22" (43.2 x 55.9 cm). Signed, lower
center. Private collection. Kallir 965

Though we associate Grandma Moses' paintings with a sort of
stability that is seemingly long lost, the Moses family in fact moved
a great many times.

Moses herself, in adolescence and young adulthood, worked as a
"hired girl" on a number of different farms. And after she married and
moved to the South with her husband, Thomas, the couple were tenant
farmers on several properties. They actually only owned two farms:
"Mount Airy" in Virginia and "Mount Nebo" in Eagle Bridge, New York.

Of the family's various moves, the biggest was undoubtedly the one
back North to the final Moses homestead in Eagle Bridge. With five
children of disparate ages, livestock, and a full house of furniture, it was a
huge undertaking. (Farm implements were generally auctioned locally or
sold with the farm.)

"We chartered a railroad car," Moses recalled, "and we brought the
stuff we had—a piano and beds and necessary things up here that way."

*By taking a car, we could bring a lot of produce, apples, meat—we
butchered a hog—a cow, hens, and stock. With the car, if there was livestock
in it, we had to have a man to take care of it. So Thomas went with the car,
but he smuggled in the two little boys, Forrest and Loyd, besides himself. . . .
In one corner was the cow tied up with the feed and the fork for manure. In
another corner was the chicken coop and in the other was the produce. The
apples made the whole car smell. And the little black and tan dog went with
them, too. So now, that was a family.*

Fig. 23. Moving Day on the Farm (*detail*)

Fig. 24. Moving Day on the Farm (*detail*)

Fig. 25. Moving Day on the Farm (*detail*)

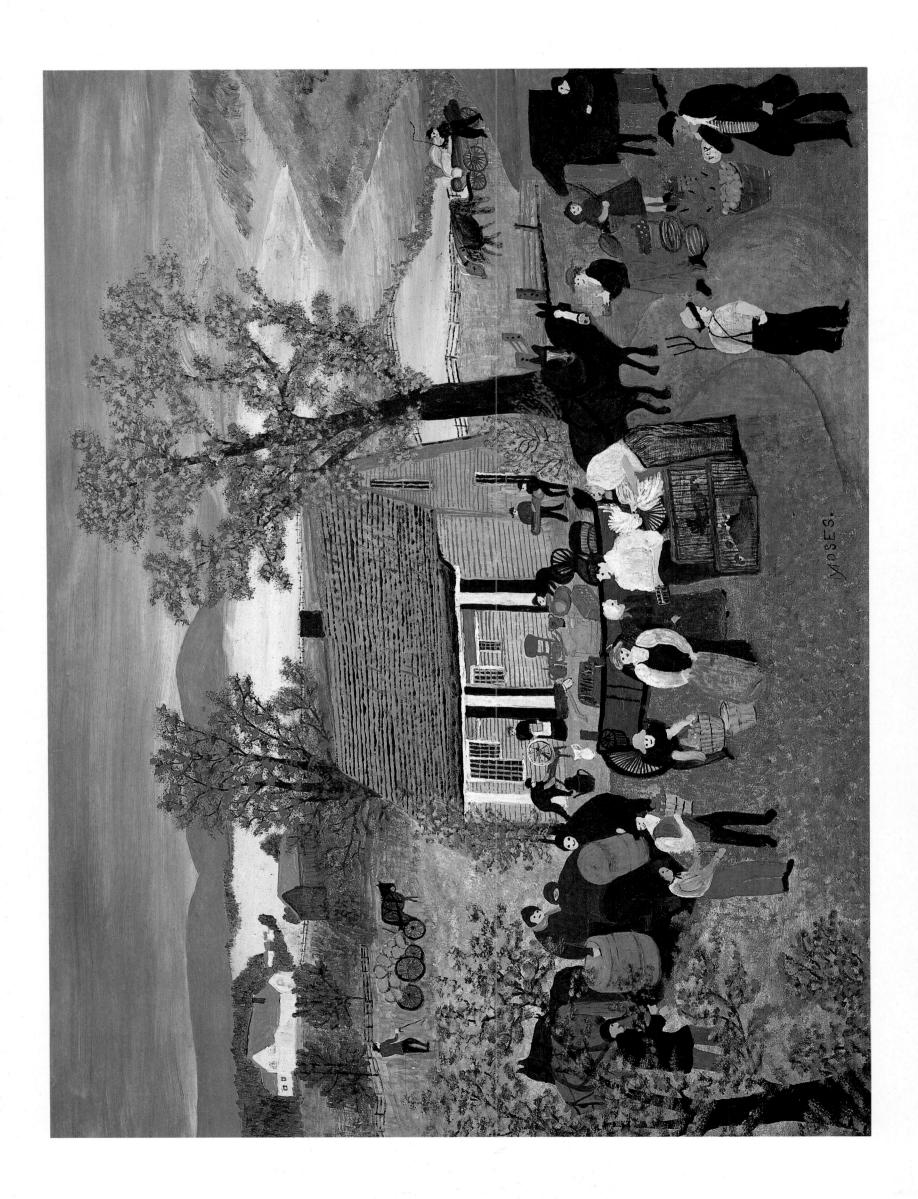

Plate 19
COUNTRY FAIR
1950. Oil on canvas, 35 x 45" (88.9 x 114.3 cm). Signed, lower right.
Private collection. Kallir 921

M oses' very first paintings, possibly conditioned by the format of
the greeting cards and prints which inspired them, had been
quite small. However, from the start of her professional career, all her
advisors—Louis Caldor, Otto Kallir, and Ala Story—encouraged her to
paint bigger pictures. With growing confidence and a surer technique,
the artist happily complied, and her mature work averages between about
12 x 16" and 24 x 27". Moses also executed about a dozen oversized
works, such as *Country Fair* (see also Plate 5), on canvases specially
provided by Ala Story. These canvases were too large for the "tip-up" table
that the artist customarily used, and instead had to be laid flat on her
bed. Moses was not entirely pleased with the results, calling them "really
too large to be pretty," but in fact the push to bigger sizes literally forced
her to expand her horizons. In these oversized paintings, she exploited the
scale to the maximum, creating a far richer and more complex
composition than would have been possible on a smaller canvas.

Country fairs were important social events in the days before modern
technology facilitated ready travel and communication. Often, these
annual gatherings were the only times that all the members of a larger
rural community would meet.

"There was a time when I would look forward from one fall to another
just to go to the fair, and summer picnics," Moses wrote.

*Those were about all the recreations we had in those days, and we would
work the year through saving our money and our clothing.*

*The first fair I ever went to was the State Fair in the year of 1876; the
grounds were between Troy and Albany. . . .*

*The first building we went through was the flower building, and oh, was
that not grand! We had a lovely flower garden at home, but not like that,
and oh it was so sweet and delightful in there. We stayed there till sun down.*

*The next morning we all went back to the fair, and this time we went
through the poultry house [and] the stove building. . . . All along one side
were cast iron cooking stoves of every description. Behind every stove was a
cook or chef and a table, and as you passed the stove, someone would pass
out to you some of the food that they were cooking on or in that stove.
Sometimes it would be hot rolls nicely buttered, then the next stove hot
gingerbread or pies, and so forth. We did not have to go home for dinner, nor
could we eat all that we got, and everything was the best. Oh, those were the
days—no hot dogs or sandwiches, that one never knows what the contents is!*

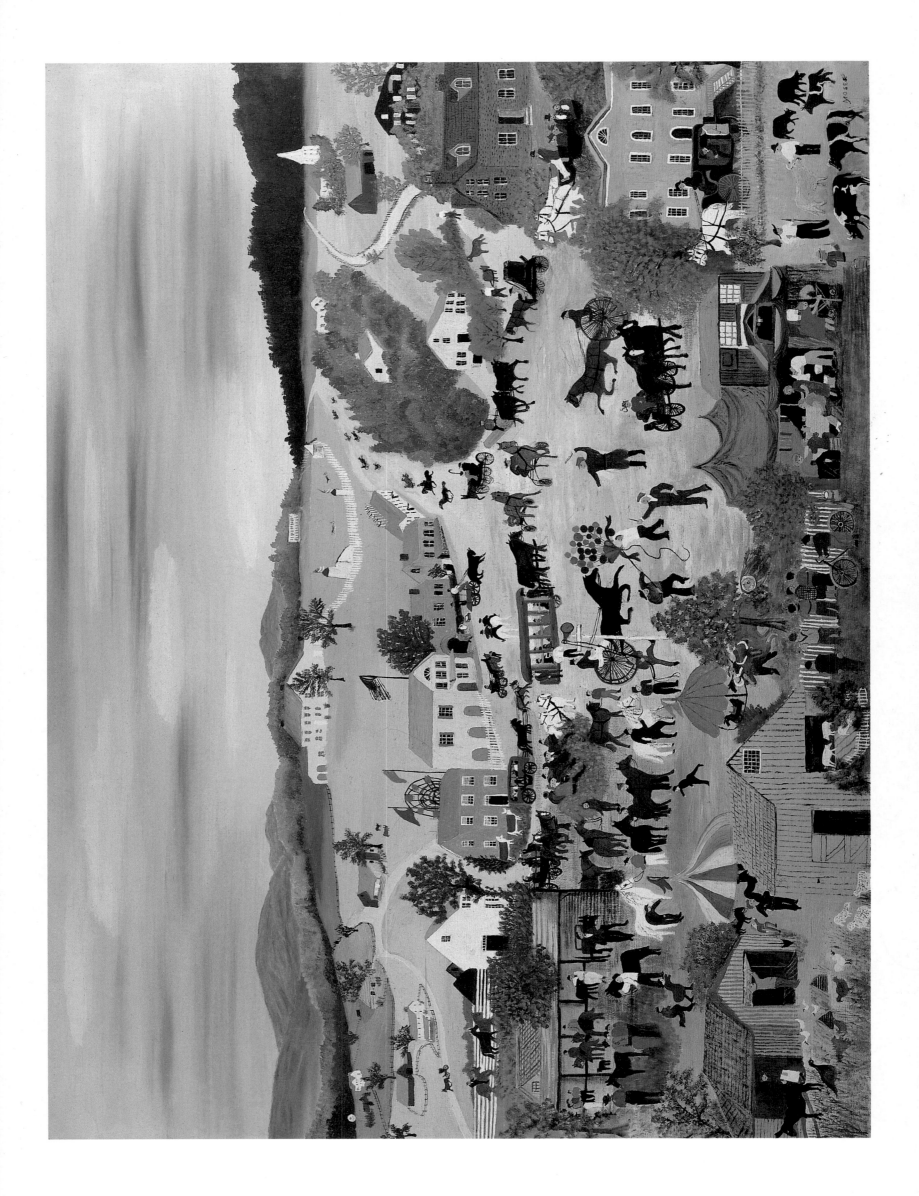

Plate 20

JOY RIDE

1953. Oil on pressed wood, 18 x 24" (45.7 x 61 cm). Signed, lower right.
Private collection, courtesy Galerie St. Etienne, New York. Kallir 1079

Few of Grandma Moses' paintings are directly autobiographical, though some observers have tried to identify the painted characters with specific people in the artist's life. On occasion, perhaps to tweak inquisitive reporters, Moses would say that she was the woman in the lavender dress (Fig. 26). At other times, however, she tended to contradict such statements.

Joy Ride is probably based on a generalized rather than a specific memory. The artist recalled that whenever there was a deep snowfall, "father would hitch up the horses to the old big red sleigh and break out all of the roads, as we lived back in the fields, probably half a mile from the main road, and father had to keep the road open."

He would drive up to the kitchen door, and we would all climb into the sleigh onto a lot of straw and blankets, and away we would go, out to the main road, then on through the woods; and oh! that was grand to drive under the hemlocks and have the snow fall on us! Then back home and around the barn, back to the house. Oh, those happy days!

Then the sun came out and melted the snow on top, and then it froze so hard, it would almost hold up a horse. It was so cold, my brothers could not go to school, and we played on the crust on the snow. We would go up a field above the orchard, get on our sleighs, and away we would go! Lester had a sleigh with cast iron runners, Horace had an old wash bench, upside down, but very safe, Arthur a dust pan, and I an old scoop shovel. Oh, what fun! We would play out for hours, and the thermometer at 25 below zero.

Fig. 26. Joy Ride (*detail*)

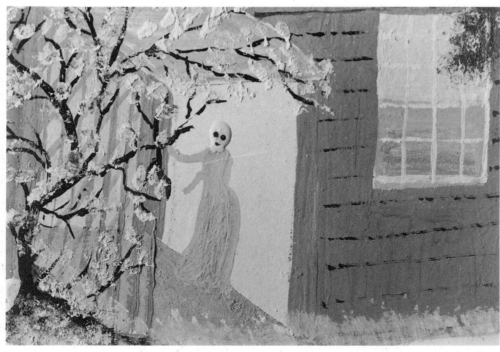

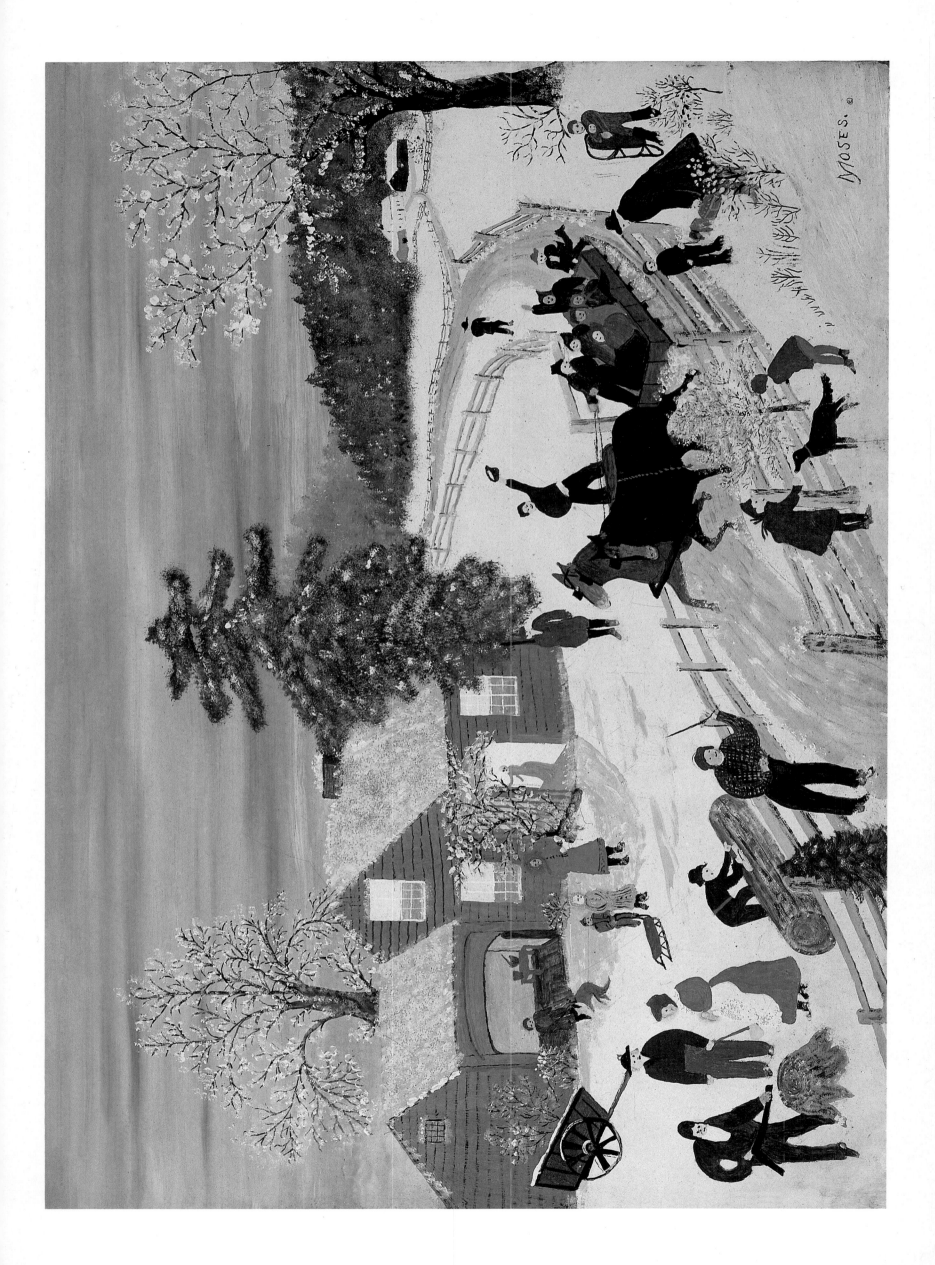

Plate 21

HALLOWEEN

1955. Oil on pressed wood, 18 x 24" (45.7 x 61 cm). Signed, lower right.
Courtesy Grandma Moses Properties Co., New York. Kallir 1188

Moses was never entirely comfortable painting interiors (see Plates 10 and 17), and one method she used to get around her discomfort was to paint cutaway, dollhouse-like views of houses. This allowed her to depict interior and exterior at once. She was always happier if she could imagine a scene in a natural setting.

Halloween is without a doubt one of the artist's most successful such "dollhouse" pictures. The landscape background sets a mood of extreme spookiness: Clouds scud across the moon, trees glow silver in the darkness, and the houses in the distance look haunted (Figs. 27 and 29). The slightly discordant palette of white, gray, green, and orange underscores this sense of subliminal unease, which contrasts sharply with the merry goings-on in the fore- and middle ground. Moses' children were cheery pranksters, and *Halloween* records a number of typical Halloween escapades: little girls dressed as ghosts (Fig. 28), boys on the roof stuffing pumpkins down the chimney, or rattling a cart of coals to make scary noises. Downstairs, the adults are preparing more sedate entertainment: Men are unloading barrels of cider, and a woman stokes the fire while children bob for apples.

Fig. 27. Halloween (detail)

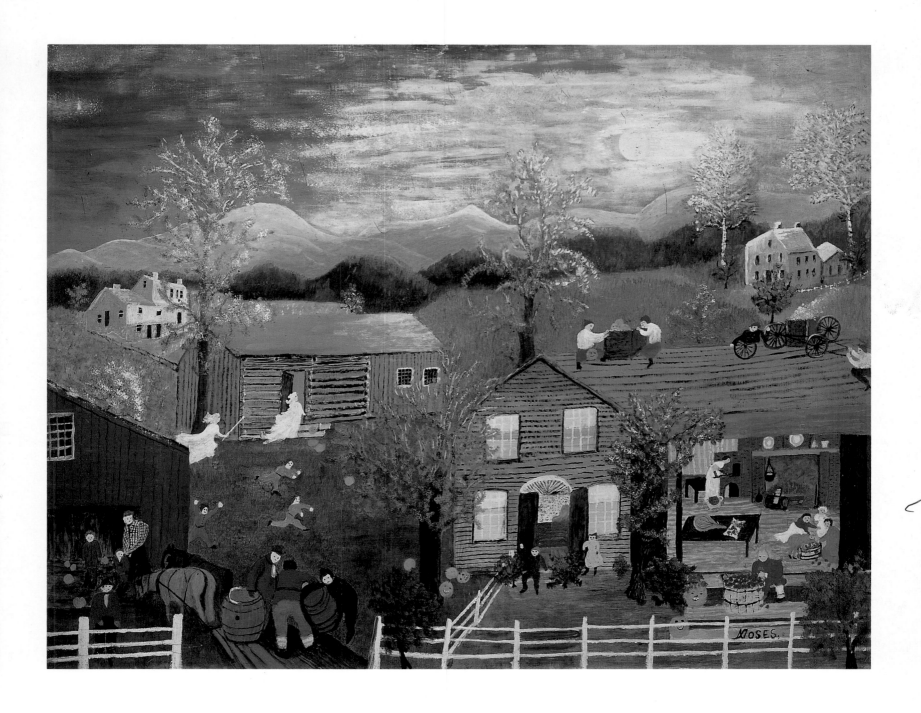

Fig. 28. Halloween (*detail*)

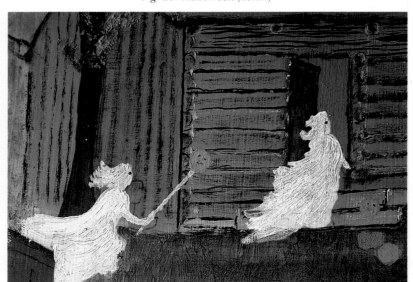

Fig. 29. Halloween (*detail*)

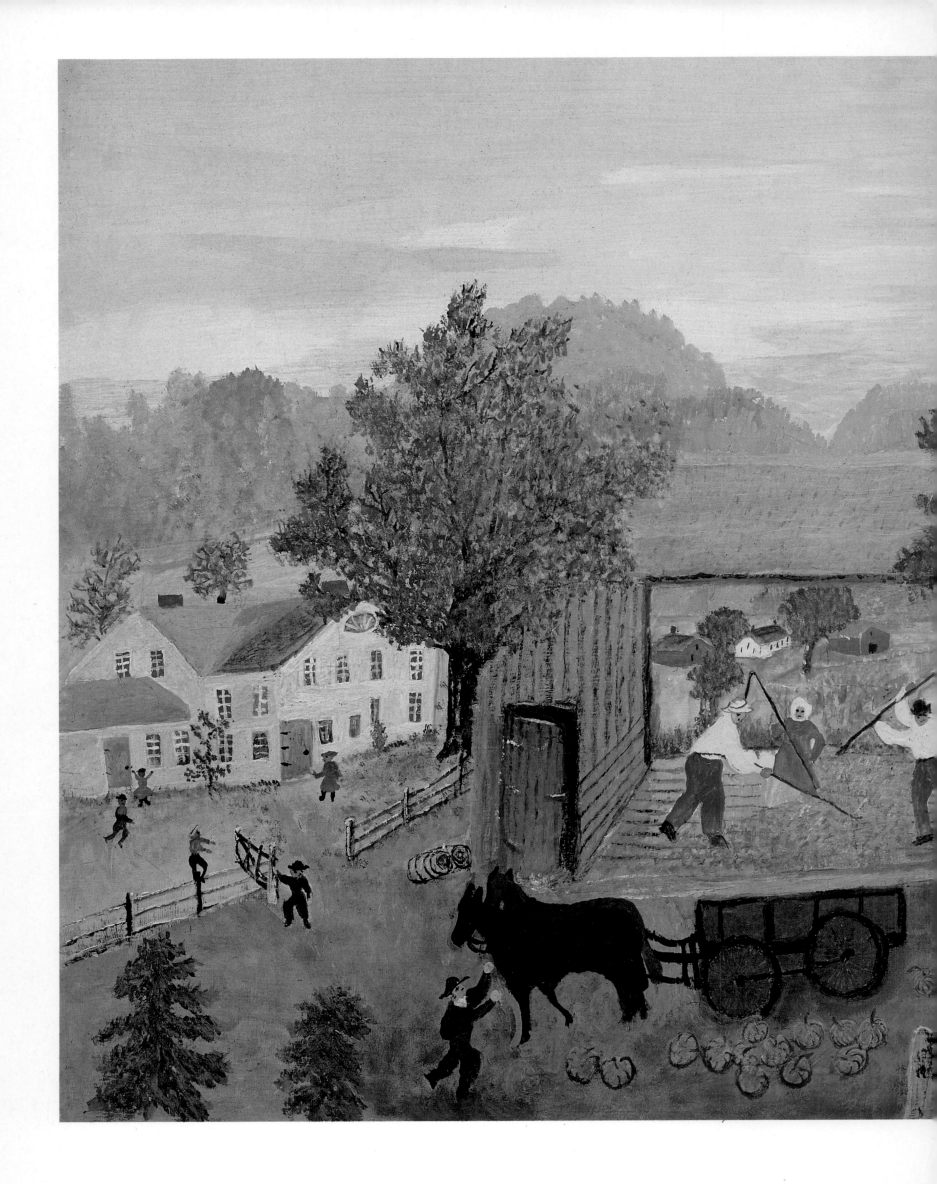

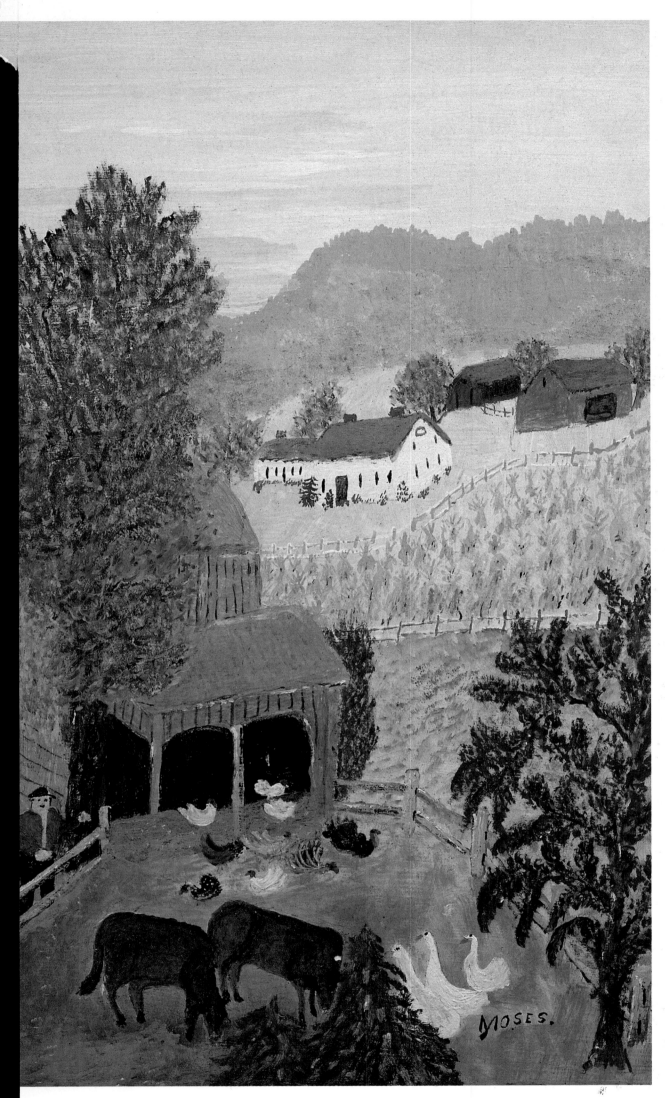

Plate 22

PUMPKINS

1959. Oil on pressed wood, 16 x 24"
(40.6 x 61 cm). Signed, lower right.
Private collection. Kallir 1380

Perhaps owing to millions of Hallmark
Christmas cards, Grandma Moses became
best known for her winter views. Given that
winter is only one of four seasons, one might
say that there is a slightly disproportionate
number of snow scenes in the artist's oeuvre,
though overall the "green" pieces are in the
majority. Rarest of all, for some reason, are fall
pictures. While the brilliant foliage of the
sugar maples and other autumn trees in the
area near Eagle Bridge is today a real tourist
attraction, such a rich palette of reds and
yellows apparently held comparatively little
appeal for Moses.

 Pumpkins, then, is something of an
anomaly. Like *Halloween* (another fall subject,
Plate 21), *Pumpkins* employs a cutaway
dollhouse view of a building. In this case, the
perspective is further confused by the fact that
the threshing floor on which the action takes
place is open both front and back. Thus we
can see the scene within the building, and
then look through it to see the landscape
behind.

Plate 23
EAGLE BRIDGE HOTEL

1959. Oil on pressed wood, 16 x 24" (40.6 x 61 cm). Signed, lower right.
Private collection. Kallir 1387

Often, self-taught artists show little evidence of stylistic growth. They seem to hit their stride with their first works and just stay there. In some cases (for example, that of John Kane or Morris Hirshfield) this is because a late-life career allows scant time for change. In other cases, the person in question does not have a great deal of intellectual curiosity about the creative process. And, finally, there are a number of folk painters who hit upon a marketable style and intentionally stick to it.

There is no intrinsic reason, however, why a self-taught artist should not develop just as a trained one does. Painting is an evolutionary process, and a visually astute person should logically examine his or her work in progress, learning from both successes and failures. Grandma Moses, above and beyond most self-taught artists, displayed an exceptional ability to learn from her work. And since, unlike Kane, Hirshfield, Pippin, and many other folk painters of her era, she lived a remarkably long life, she had a chance to explore her creative potential to its fullest.

It may seem ironic to speak of an "old age" style in someone whose career did not effectively start until she was 80, but in fact the last works of Grandma Moses evidence a conceptual kinship with the later work of other long-lived painters, such as Rembrandt. There is a comparable loosening of brushwork and similar shorthand approach to form in Moses' paintings from the late 1950s and early 1960s. In *Eagle Bridge Hotel*, the human and animal figures are painted with far less precision than one finds in works from the 1940s. The foliage is daubed erratically onto the trees, and a narrower horizontal format forces more compression of detail. As a result, the artist's message is telegraphed with much greater immediacy than was formerly the case. The overall impression is significantly more spontaneous, more expressionistic.

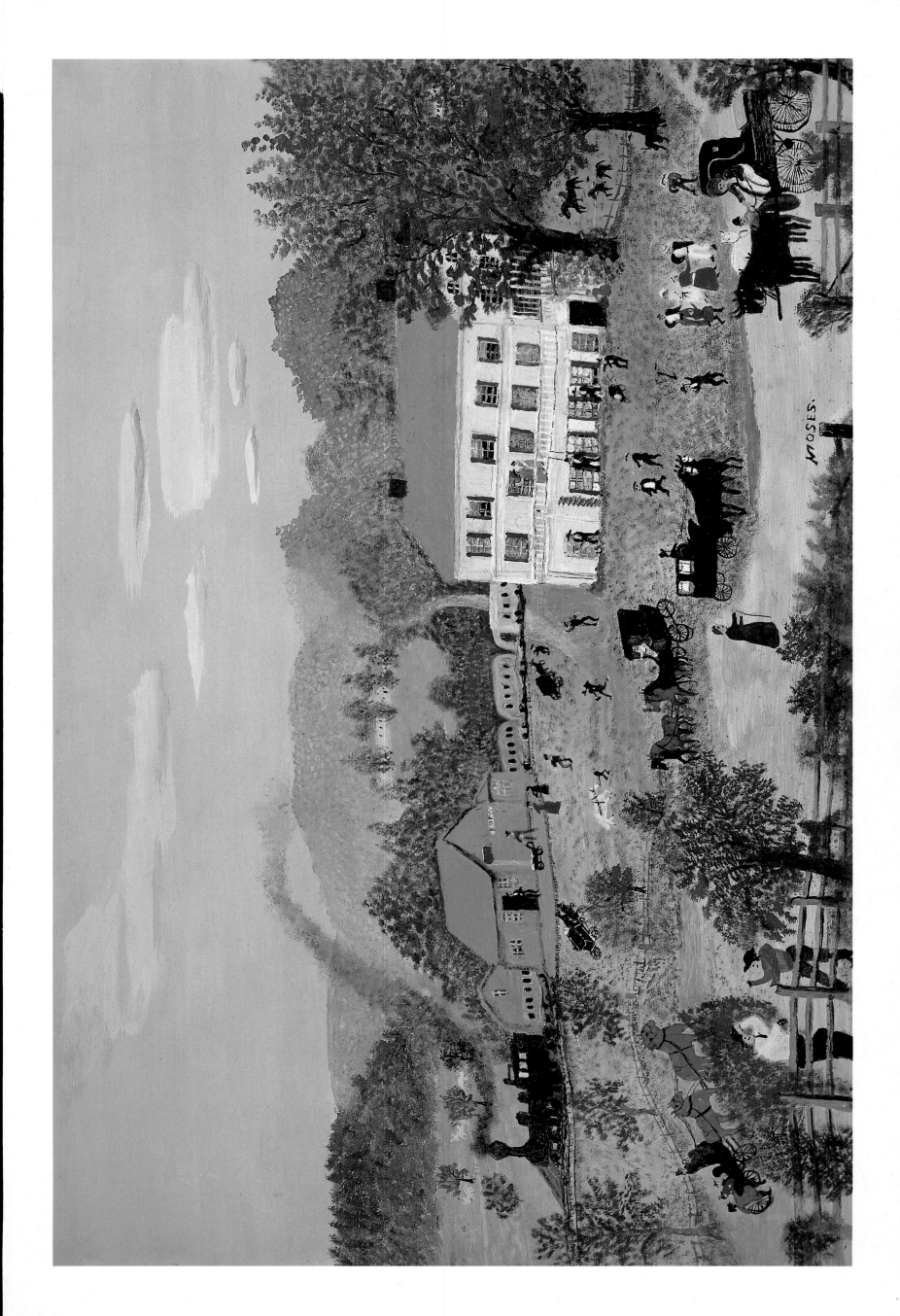

Plate 24
SO LONG TILL NEXT YEAR
1960. Oil on pressed wood, 16 x 24" (40.6 x 61 cm). Signed, lower right.
Courtesy Grandma Moses Properties, New York. Kallir 1461

Although Grandma Moses was always open to new challenges, she resisted attempts by outsiders to dictate to her in terms of style or subject matter. "Someone has asked me to paint Biblical pictures," she once noted, "and I say no, I'll not paint something that we know nothing about; might just as well paint something that will happen a thousand years hence."

Nevertheless, despite her staunch adherence to the factual and true, less than two years before she died Moses acceded to a request to illustrate a children's book, Clement C. Moore's famous poem, "The Night Before Christmas." Just as she rose to and ultimately mastered the challenge of painting interiors (see Plates 10 and 17), Moses—even at the age of nearly 100—was ready to risk something completely untried. Unfortunately, she did not live to see the publication of *The Night Before Christmas*, which appeared in 1962 and remained more or less continuously in print for the next three decades.

While many of the *Night Before Christmas* illustrations dutifully follow the text of the poem, *So Long Till Next Year* is pure fantasy on Moses' part. Not actually published in the original edition of the book, it is nonetheless in many ways the quintessential Christmas painting by an artist who was famous for such subjects. Unlike most of Moses' snowscapes, which are clearly grounded in nature, the blue background of *So Long Till Next Year* immediately informs us that we are in the realm of the imagination. The scenery is etched on this background in a frosty filigree, like icicles on a window pane. Above all, *So Long Till Next Year* demonstrates Moses' exceptional flexibility and versatility.

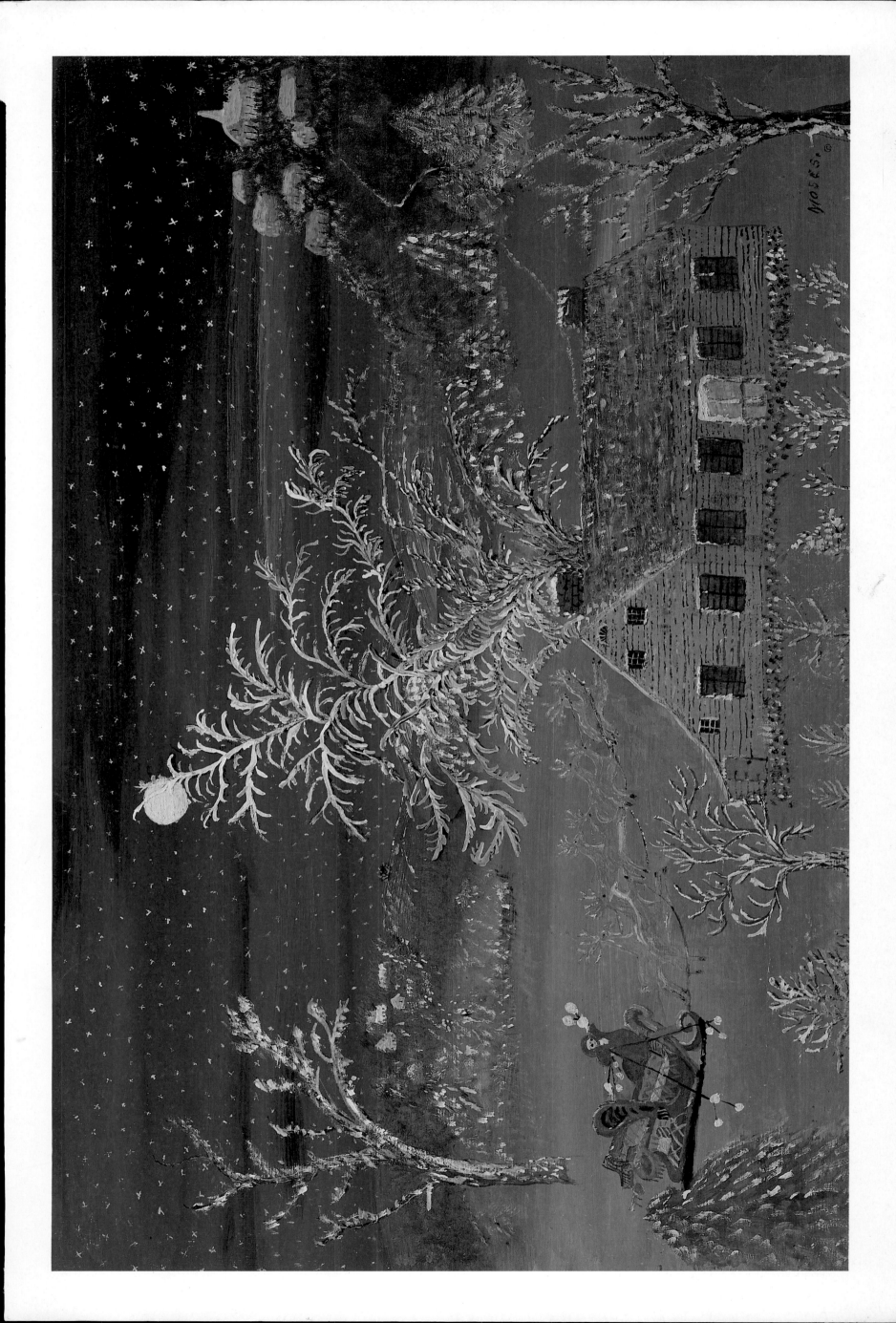

Plate 25
THE RAINBOW
1961. Oil on pressed wood, 16 x 24" (40.6 x 61 cm). Signed, lower right.
Private collection, courtesy Galerie St. Etienne, New York. Kallir 1511

Grandma Moses continued to paint well into her 101st year,
although during the last few months of her life she was too weak
to do any work. *The Rainbow*, executed in June 1961, is generally
considered her last finished picture. As such, it is an amazing distillation
of the artist's world view as well as of her final style.

Like *Eagle Bridge Hotel* (Plate 23), *The Rainbow* represents Moses'
"old age" style in all its glory. The paint handling has become quite wild,
nearly expressionistic. This facilitated a joyous free-for-all of color (Fig.
30). Figural vignettes, once so clearly set off from the landscape, here
merge with their surroundings: Nature and humankind are at last one.
Moses is no longer terribly concerned with representational accuracy in
her use of color; the emotional impact is paramount. The exuberant swish
of the scythes, candy-striped in yellow, white, and red, and the spun-
sugar puff of pink flowers, out of which a hay wagon rises like a small
triumphant chariot (Fig. 31), are presented as bright symbols in paint,
tokens of peace, an offering of hope.

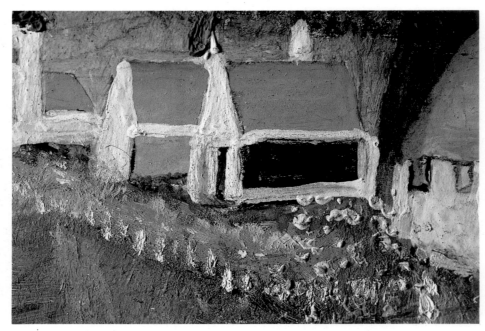

Fig. 30. The Rainbow (detail)

Fig. 31. The Rainbow (detail)

54

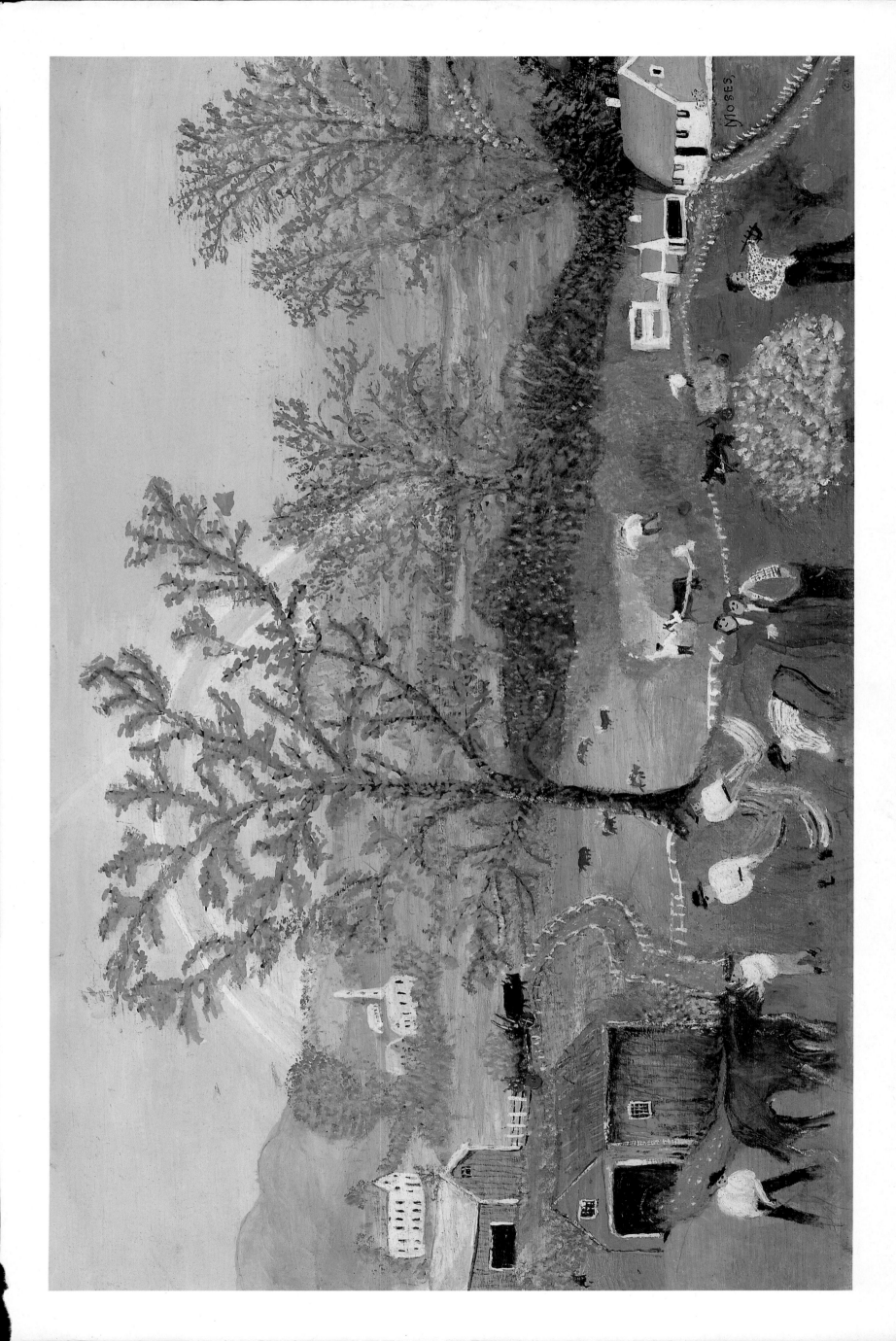

I would like to convey my warmest thanks to Hildegard Bachert
for her advice and assistance in the preparation of this manuscript.

Project Director: Margaret L. Kaplan
Designer: Judith Michael
Photo Permissions: Michele Adams

Frontispiece: Fig. l. Grandma Moses at work. 1946. Photograph by Otto Kallir
Cover: Plate 18. *Moving Day on the Farm.* 1951. Private collection. Kallir 965

Quotes by Grandma Moses from:

Otto Kallir, ed., *Grandma Moses, American Primitive,* New York: Dryden Press.
 Copyright © 1946 (renewed 1974), Grandma Moses Properties Co., New
 York.
Grandma Moses, *My Life's History,* New York: Harper & Brothers. Copyright ©
 1952 (renewed 1980), Grandma Moses Properties Co., New York.
Grandma Moses, *Christmas,* New York: Galerie St. Etienne. Copyright © 1952
 (renewed 1980), Grandma Moses Properties Co., New York.
Jane Kallir, *Grandma Moses: The Artist Behind the Myth,* New York: Clarkson N.
 Potter. Copyright © 1982, Grandma Moses Properties Co., New York.

Captions for paintings include references to the pertinent entries in the catalogue
raisonné by Otto Kallir, *Grandma Moses,* New York: Harry N. Abrams, 1973.

Photo credits: Geoffrey Clements, New York: plate 6; Eric Pollitzer, New York:
plate 25; Jim Strong, New York: plate 8, plate 24.

Library of Congress Catalog Card Number: 96–80430
ISBN 0–8109–2697–0

Illustrations copyright ©1997 Grandma Moses Properties, Inc.
Text copyright © 1997 Jane Kallir

Printed and bound in Japan

Harry N. Abrams, Inc.
100 Fifth Avenue
New York, N.Y. 10011
www.abramsbooks.com